IMAGES
of America

HOT SPRINGS

ARKANSAS

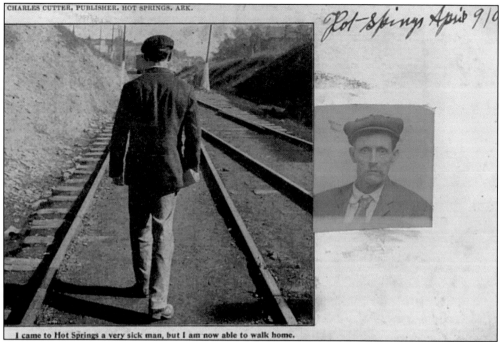

Hot Springs April 9/0

I came to Hot Springs a very sick man, but I am now able to walk home.

By the countless thousands, visitors flocked to Hot Springs during the latter years of the 19th century and first decades of the 20th century. They came in large part to partake of the hot waters that bubbled from the earth, water that, when bathed in and drunk, was thought by many to heal a variety of ailments. The 1909 card shown above carries the tongue-in-cheek caption, "I came to Hot Springs a very sick man, but I am now able to walk home." The sender had glued his own photo on the card and written, "They got all my money, but I am feeling fine. Will be home the 15th if I don't have to stop and get my shoes half soled." Below, a 1903 card, showing visitors strolling with the Arlington Hotel in the distance, conveyed the reality of the Spa City in these words, "Greetings from the City of Invalids and Cripples."

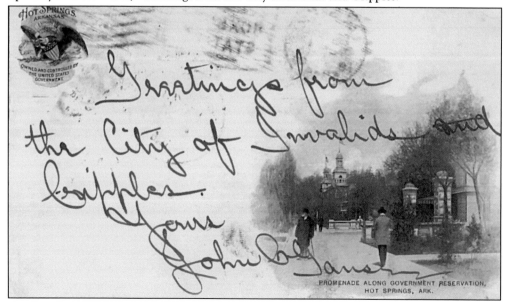

PROMENADE ALONG GOVERNMENT RESERVATION, HOT SPRINGS, ARK.

IMAGES
of America

HOT SPRINGS
ARKANSAS

Ray Hanley and Steven Hanley

ARCADIA
PUBLISHING

Published by Arcadia Publishing
Charleston, South Carolina

Printed in the United States of America

Library of Congress Catalog Card Number: 00-103179

For all general information contact Arcadia Publishing at:
Telephone 843-853-2070
Fax 843-853-0044
E-mail sales@arcadiapublishing.com
For customer service and orders:
Toll-Free 1-888-313-2665

Visit us on the Internet at www.arcadiapublishing.com

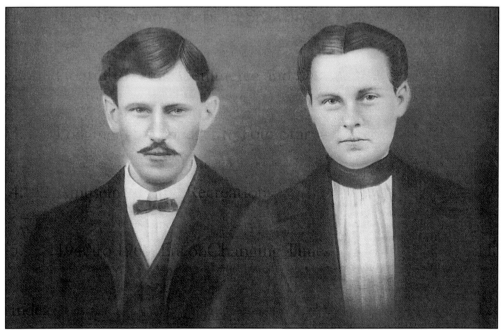

This book is dedicated to the memory of Hot Springs firefighter George Ford (pictured above with his wife), who lost his life beneath a falling wall while fighting the April 5, 1923 fire that destroyed the Arlington Hotel. In addition to his wife, Ford left behind seven children. He symbolizes the men and women who have often risked their lives to protect Hot Springs over the years from fire, floods, and other hazards. (Photo courtesy of Hot Springs Fire Department.)

CONTENTS

ACKNOWLEDGMENTS

The authors owe major thanks to Mark Blaeuer of the Hot Springs National Park staff for helping make this book possible. It was Mark's knowledge, research skills, and love of the city that gave us a great deal of the information that accompanies the images in this book. Both Mark and the National Park Service are to be commended for keeping alive the history of the Spa City. Special thanks go also to Diane Hanley for her faithful, often late-night, editing job on this book.

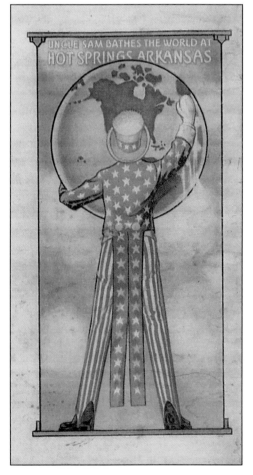

For decades the resort city promoted the claim that "Hot Springs Bathes the World." In this illustration from a U.S. government publication around 1910, it is Uncle Sam himself scrubbing the world, indicative of the fact that the federal government owned and managed the reservation that was to become Hot Springs National Park.

FOREWORD

Over 99 percent of Hot Springs' history is non-pictorial. For thousands of years, Native Americans lived in the area. Descendants of the Caddo, Quapaw, and Choctaw tell their own myths about the past, and archeological remains utter bedrock facts in the language of science, but native pictographs (paintings) and petroglyphs (drawings carved in stone) are few and far between in Arkansas.

After European explorers and pioneers arrived, the merest sketch was rare before the mid-19th century. Most images were conjured by words in a diary, a report, a letter, a book chapter, or a legal document; students of local history are grateful for every scrap preserved. The first photographs of Hot Springs date from the 1860s. Among the best are those of T.W. Bankes, J.F. Kennedy, Clary & Urie, and others who lugged heavy cameras with double lenses. These entrepreneurs made and peddled stereographs (cards with two near-identical exposures) for mounting in stereoscopes. A craze for these hand-held devices swept the country, and every Victorian parlor had one, affording three-dimensional views of landscapes often deemed exotic.

Hot Springs qualified as exotic then, a premier spa on the fringe of the American West. The Gilded Age (1870s–1890s) coincided with the birth of the Golden Age of Bathing in Hot Springs. Spring water was good for what ailed you, and nature lavished its wondrous medicine on pilgrims who traveled on bumpy stagecoaches (or, later, the railroad) to "take the cure." In 1820, the Arkansas Territorial Assembly had requested that Congress make the springs a federal preserve, so that all the sick and needy, not just the privileged class that frequented Eastern U.S. resorts, might benefit. In 1832 Congress complied, creating Hot Springs Reservations, the forerunner of what is now Hot Springs National Park. The park story is in large measure the story of its concessions, the bath houses that carried out the government-mandated mission. The bath house owners, though, had their fingers in various financial pies. Sam Fordyce, who built the Palace Bath House as well as the edifice named for him, owned the streetcar line. William Sorrells, co-owner of the Ozark Bath House, was also proprietor of a fine drug store. Sidney Nutt, owner of the Lamar Bath House, operated movie theaters downtown. Hot Springs evolved alongside Bath House Row, providing essential services to a burgeoning populace. In time, the city was as much a destination as the "National Sanatarium." It was a place for fun and a place to settle, not simply a center for convalescents.

This was the perfect market for postcards. For a penny, visitors and residents alike could mail a glimpse of the world-famous Valley of Vapors (with handwritten commentary pro, con, or indifferent). Postcards thoroughly evicted stereographs from the commercial arena. Yes, images were sometimes artistically enhanced, but the overall reflection of society was less sanitized than one might think. Even disasters were chronicled, and the pictures occasionally shock present-day sensibility.

If the initial 10,000 years are wrapped in legend or seen darkly through the glass of academia, the last hundred are clear as the steamy water flowing at the base of Hot Springs Mountain. The humble postcard helped.

—Mark Blaeuer, Park Ranger
Hot Springs National Park Visitor Center (Fordyce Bath House), March 2000

"O came we to a valley that lay between great green hills.
And there was water of exceeding hotness, so that we were affrighted,
bethinking ourselves of Death and the nearness of the fires of Hell.
Anon there came dark red men and their women down the valley,
and trod the strange grey rocks without fear, and bathed in the waters, laughing and making great joy.
Then we were no longer afeard, but knew it was a sweet warm Well of Life."

—from *The Padres' Chronicle*

The passage above was reprinted in a 1912 guide to Hot Springs published by the Illinois Central Railroad. The tale, of uncertain origin, purports to tell of the first glimpses of the area by European explorers. Unsubstantiated legend has it that Spanish explorer Hernando De Soto discovered the springs on his journeys around the year 1541, but no historical verification exists to prove the legend.

Regardless of who first followed the Native Americans into the valley of the vapors, the wonder expressed in the passage from The Padres' Chronicle captures very ably the reaction of many of the early visitors to the area. A combination of Mother Nature's magic and the architectural works of the Victorian era gave the nation one of the most unique spa cities in the world. Many impressions of this Victorian period in Hot Springs, both in photographs and in the written words of visitors, have been preserved on picture postcards. These Hot Springs cards from the early 20th century, combined with photographs that began to appear soon after the Civil War, together provide an invaluable record of a special time and place—a setting that in many ways remains to be experienced today.

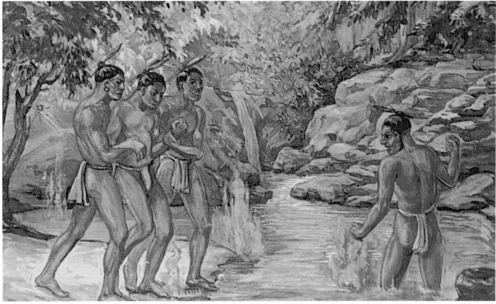

We know the first visitors to the hot springs were Native-American tribes, but how they lived and used the springs is lost to history and is steeped in legend. This card shows a group of braves assisting an injured warrior into a hot spring pool. The back of the card reads, "Raids by the fierce Osage from the north often inflicted serious wounds among Caddo warriors. Regardless of tribal hostility, the hot springs area remained neutral ground in which both sides could rest and heal their wounds in peace." The oft-repeated "neutral ground" legend may be true, or may be only a charming speculation.

INTRODUCTION

In 1832, four years before Arkansas statehood, President Andrew Jackson signed a law placing the unique hot springs area under the protection of the federal government. Log hotels and bath houses had already sprung up around the springs, and there was concern about protecting their wonders for future generations. This was the "first" time in American history that land was set aside for specific recreational purposes, even more amazing in that it would be some 40 years more before the country's first national park was created at Yellowstone National Park covering areas of Wyoming, Idaho, and Montana.

The area's remote location, in an era of rough roads and unreliable transportation, kept the Hot Springs population sparse for many years. Only 84 residents were counted in the 1851 census, when the City of Hot Springs was incorporated. After the Civil War, new residents began to flood into the area, some laying claim to the springs themselves. It took a declaration by the United States Supreme Court in 1876 to firmly establish the right of the federal government to regulate development on the more than one thousand acres surrounding the springs. It was this Federal Reservation status that would be changed in 1921 for Hot Springs to become an official National Park.

By 1900, Hot Springs was one of the grandest resorts in the world, drawing visitors from around the globe. Visitors especially came from northern U.S. cities like Chicago, in order to escape harsh winters and to partake of the fabled healing of the hot spring waters. For almost two decades after this time Hot Springs was a Victorian wonder to behold, and one of the most popular tourist resorts in the nation. The Hot Springs tour guides published by the competing railroads offer some of the best written records of how the healing properties of the waters and the gaiety of the city's social scene were promoted to potential visitors and rail passengers.

A 1910 booklet printed by the Illinois Central Railroad poetically claimed, "When Mother Earth discovered that her Great Maker had populated this world with human beings, she knew that youth was precious. In a mammoth storehouse, she established a treasury of remedies of her own making for human ills, senility and weariness. This she dedicated to the world and its people. It is known as Hot Springs, and lies in the land of the Ozarks, in Arkansas." The booklet went on to point out, "To look about in the ancient Grecian and Roman cities and see the ruins of the once magnificent bath houses, is to wish that one had been entitled to the privileges of those times. And yet, right in our front yard we have the same advantages. For the baths at Hot Springs have one other function that is of no less importance than that of curing the sick. They establish good health!"

"To bathe in the warm waters of Hot Springs is to feel the hand of nature in one of her sublimest moods upon your body, gentle, caressing, curative and resting, all without exertion or pain. No heroics greet the sufferer at the baths of this famous garden of health. Do as you please, bathe or drink, exercise, work or play—no one objects. It is an Eden for the sick—a Heaven for the tired and the weary. It is a necessity for the rich man, a possibility and a probability for the poor man."

The United States Railroad Administration published a booklet around 1915 with glowing recommendations for the baths of Hot Springs: "The spirit of Hot Springs creeps into the veins of the newcomer unawares. The average visitor enters the valley fagged out mentally and

physically. He is the victim of too much applied energy in one direction, and a sense of relief, of freedom from care, steals over him as he establishes himself in his commodious quarters and prepares for a good rest. When he enters upon his course of baths, his business or domestic problems, though pigeonholed somewhere in the back of his head, have not been entirely forgotten. For the first few days he lies upon his cooling-room couch, his body relaxed, his eyes closed, his ears deaf to the voices of those around him. Then, suddenly, he awakes. A new and unusual feeling of animation possesses him. His blood is beginning to tingle. His old time energy is coming back to him and his thoughts are turning to golf, to tennis, to horse-back riding other amusements. Then it is that he begins to appreciate what is happening to him, to understand that the baths have driven all sluggishness from his blood, have give him the energy not only to work but to play and have created in him the desire to play. And he plunges joyfully into the whirlpool of Hot Springs activity."

The Missouri Pacific Railroad in its 1909 promotional booklet went even further in making bold health claims about the waters: "To undertake to give a complete list of cures that have been effected would be like trying to name all the ills that escaped from Pandora's box. It would be impossible, but official reports declare the waters have cured well nigh every disease to which the flesh is heir." The booklet cited the reports of the Surgeon General of the U.S. Army to say the waters cured diseases ranging from rheumatism, malaria, and liver disease, to chronic diarrhea and lung "troubles." The same booklet reported that the bath houses had a combined total of 600 tubs, capable of administering 8,000 baths a day. The railroad advised that a stay in Hot Springs was affordable, ranging from $46 to $145 per month, which included lodging, meals, and bathing expenses. The Missouri Pacific publication also stated, "It is a well known fact that these waters are the only hot waters in America which can be drunk freely without causing nausea. A folding cup is part of the equipment of every tourist, and as one wanders along the beautiful walks and thoroughfares of Hot Springs, one cannot resist the temptation to stop at every fountain and quaff the pure Adam's ale as it flows piping hot from the secret urns of good old Mother Nature."

The Illinois Central Railroad booklet elaborated on the natural setting of Hot Springs, as a further inducement to buy a train ticket: "Hot Springs is one of the most beautiful places in the world. Ministers of the gospel, senators, physicians and world-renowned surgeons and just people—flock to this little corner of the world where happiness is served with each breath of the pure mountain air. Imagine for one brief moment if you please, the peculiar virtues of the climate of Japan, the sharp, invigorating life-giving ozone of the mountainous Switzerland, the mild and restful winds of the Florida coast, and the continual evenness of the climate of the South Central United States. These, all rolled into one, constitute the climate of Hot Springs. One square night's sleep in that famous Hot Springs air is worth months of a doctor's care in the city. You are truly refreshed."

As the 20th century and modern medicine advanced, belief in the healing powers of the hot waters faded. One by one the bath houses closed down and the hotels burned or were razed, to the point where today there remains only one operating bath house, the Buckstaff, though several hotels still offer bathing facilities. Much of the legacy of Hot Springs' storied past remains, however, through preservation efforts of private parties and the National Park Service. It is hoped that a nostalgic trip through the pages of this book will inspire a visit to the present Hot Springs of Arkansas, springs that inspired the following poem, "Red Wing's Rejuvenation," of an Indian brave long ago:

At the pool of Sparkling Waters,
Red Wing loosed and dropped his deerskins,
Laved the fever from his forehead,
Shook the stiffness from his shoulders,
Steaming hot the purling waters,
Hot and quick the bubbling waters,
As he plunged beneath their surface,

Wallowed in their hissing vapors . . .
When the joints begin to stiffen
And a fever grips the tissues,
Hearken to the lilting waters,
To the hot and healing waters,
In the foothills of the Ozarks.

One

THE RISE OF AN AMERICAN SPA CITY

The grand future that had been envisioned for Hot Springs around the middle of the 19th century suffered a major setback with the coming of the Civil War. The area's able-bodied men marched off to battle, and bushwhackers burned much of the town. All but a tiny handful of the town's citizens fled the area, many going to Texas. However, Hot Springs would revive after the war, for the draw of the springs brought back residents and those intent on developing a resort around the geological wonders.

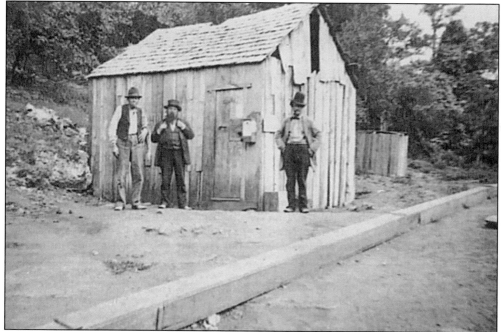

In the first few years following the Civil War, development around the springs was often crude and unregulated. Some bath houses were little more than rough shacks, often built directly over the springs, as seen in this c. 1875 stereoscope card. Concerned about unregulated development and questionable claims on surrounding lands, the federal government took the issue to the United States Supreme Court; in 1876 the Court nullified the competing claims and firmly established government ownership of the springs, thus insuring protection of the resources and orderly future development. (Photo courtesy of Arkansas History Commission.)

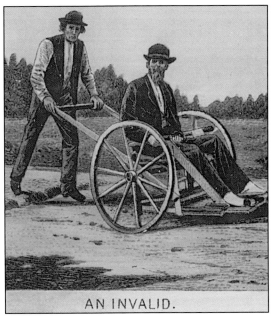
AN INVALID.

During the 1870s transportation into Hot Springs moved along rough roads that were improved only slowly, yet the sick and lame began to come in great numbers. One visitor described the scene around one open spring as follows: "Here may be seen at all times of the day, but more especially morning and evening, the halt, the lame, the blind, some with contracted or crooked legs, or arms, others with a stiff knee, ankle or arm, enlarged or swollen joints, gout, skin diseases, boils, tumors, syphilitic affections, etc." An invalid is shown here being wheeled to a spring in a crude cart modified to serve as a wheelchair. (Courtesy of Arkansas History Commission.)

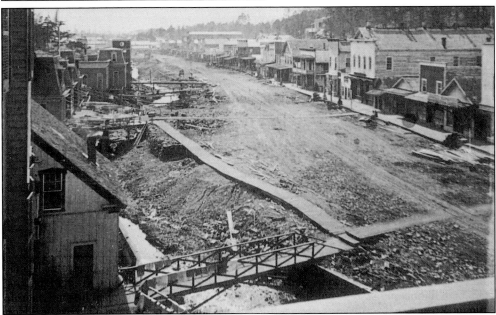

Central Avenue, known initially as Valley Street, was the heart of the main business and bath house district. The muddy thoroughfare was lined with frame structures to host the visitors that began to come in the 1870s. Hot Springs Creek, seen to the left of the road in this view, was an open ditch that often drew criticism from visitors, such as this penned by a New Yorker in 1876: "When I add that there must be millions of pigs of all sizes and colors running at large, you can understand how unpleasant pedestrianism must be. Hot Springs Creek runs along the valley and crosses the road a least a dozen times in a mile, there are no bridges except foot bridges." In the mid-1880s the creek was covered over in the manner of a storm drain, creating a broad walkway running in front of the bath houses. This c. 1880 photo was taken from the one of the porches of the Arlington Hotel.

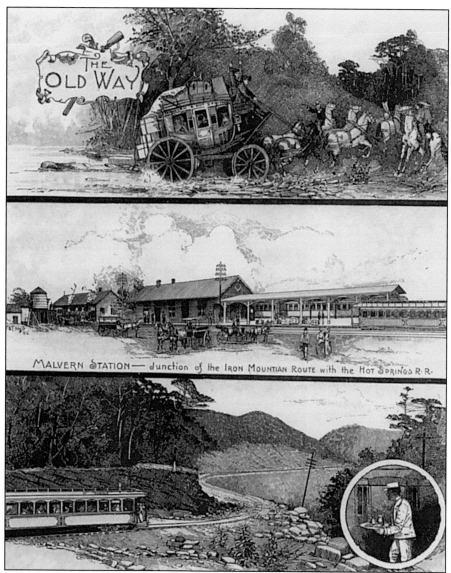

THE OLD WAY

MALVERN STATION — Junction of the IRON MOUNTAIN ROUTE with the HOT SPRINGS R.R.

Travel into Hot Springs was rough and hazardous for decades, with stage travel beginning around 1836. By the 1870s visitors could come by train as near as Malvern, some 20 miles distant, but still had to switch to a stage for the jarring ride over a rough mountain road. Stage robberies were a particular hazard; at least one of these was thought to have been committed by Jesse James. One complaining visitor expressed hope in 1873 that before another year "the iron horse with its shrill whistle would be heard throughout these valleys and mountain tops." In 1874, a wealthy northern robber baron named "Diamond Joe" Reynolds made this wish a reality. He had come to Hot Springs for the treatment of his rheumatism and vowed to replace the stage with a train, for he intended to return to Hot Springs often and in the comfort he could afford. Reynolds built a narrow gauge railroad from the depot at Malvern (center picture). Travelers bound for Hot Springs then left their large Pullman coaches for the smaller but richly appointed narrow-gauge railcars seen in the bottom drawing. Officially the line was called the Hot Springs Railroad, but to most it was the "Diamond Joe." (Courtesy of Arkansas History Commission.)

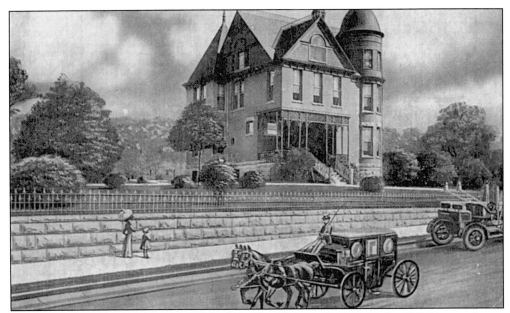

The Diamond Joe Sanitarium, named for the railroad baron, was operated at 313 Cottage Street by Dr. and Mrs. J.W. McClendon, who also lived in the facility. One of several sanatoria in the city, such a business was a cross between a hotel and bath house. It offered lodging and bathing, with the implication of greater medical benefits due to the physician on-premises. Dr. McClendon was elected mayor of Hot Springs in 1913, the same year the building was destroyed in a fire that ravaged 50 blocks of the city.

Visitors to Hot Springs came both to bathe in the water and to drink it, ascribing healthful benefits to both uses. This group was photographed around 1890 on a visit to Arsenic Spring at 103 Mount Ida Street. The man in the center is holding a glass of water taken from the fountain to the left. Arsenic Spring has been used since before the Civil War and may still be visited—the business is not closed.

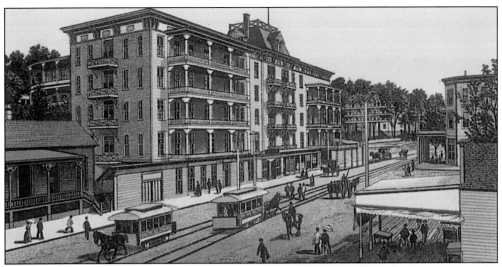

By the 1880s, frequent and full-scale railroad service made Hot Springs a booming spa city for visitors of means who expected luxury as they enjoyed the baths and attractions. Among the finest lodging of the era was the Avenue Hotel (above), which was erected on a slope on Park Avenue behind the present site of today's Majestic Hotel. Completed in 1881, the Avenue had 170 rooms and advertised that it could accommodate 300 guests. For guests' convenience, the bath department was built into the hotel, a new feature of the era. Located further down Park Avenue was the Waverly Hotel (below), which occupied the site where later stood the Velda Rose Motel. The Waverly advertised itself as the "leading family hotel" of the city, and offered among its amenities hair-stuffed mattresses on the beds. Its elevator was equipped with an air cushion that was said to make it "absolutely safe." For guests traveling to and from the bath houses of Central Avenue, the hotel furnished a closed carriage in order to "prevent liability of taking cold after bathing." A branch bank occupies the site today. (Courtesy of Arkansas History Commission.)

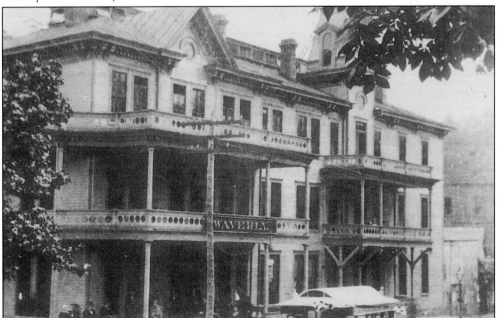

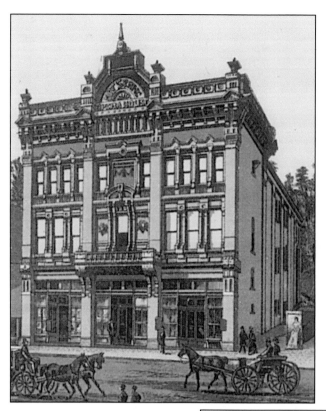

Hot Springs took a great cultural leap forward in 1882 when Union Army veteran and railroad builder Samuel Fordyce led the drive to build the Hot Springs Opera House at 200 Central Avenue. It was finished with a galvanized iron front, and was one of the most striking buildings in the city. It was furnished with red velvet seats, carpets, and tapestries. Unique features found in no other opera house in the country included the exits, which from each balcony led directly out upon the side of West Mountain. Unlike many small-time opera houses, the Hot Springs venue fostered a demand for quality entertainment and drew plays directly from New York with leading players of the day. The lower image was taken around 1960; the building was torn down in 1962.

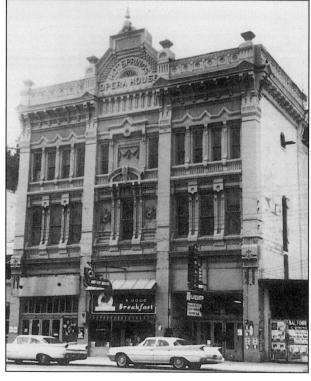

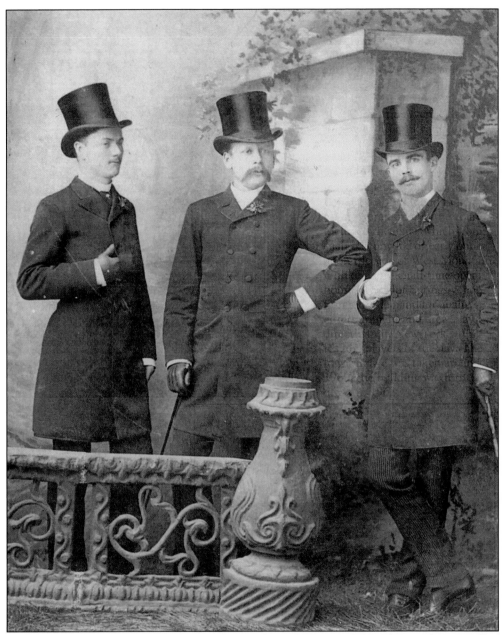

Among the acts that played at the Hot Springs Opera House in the 1880s was the trio called the "Lone Stars." When performers of renown came to the opera house the pomp and ceremony rivaled that of the largest cities. Among those who played on its stage were General Tom Thumb of P.T. Barnum fame, James O'Neill (father of playwright Eugene O'Neill), and Lillian Russell. Opening nights for productions like *Rip Van Winkle* would find ladies alighting in full evening dress from coaches parked on Central Avenue; guests were met by tuxedo-clad ushers upon entering the theater. Perhaps the best-known production was *The Wizard of Oz* in 1904, though the most commonly run productions were traveling minstrel shows. The city's theater business shifted early in the 20th century from the Opera House to a new civic auditorium on Benton Street.

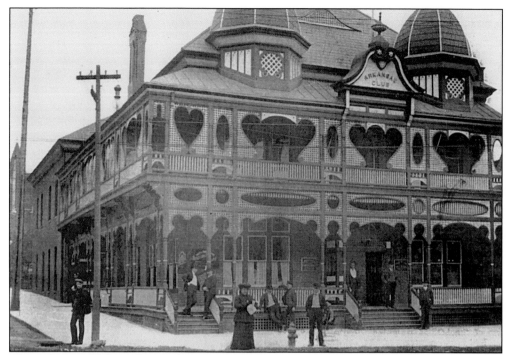

The Arkansas Club at the southeast corner of Spring and Valley Streets was an upper-end saloon and gambling house, and also by some accounts a brothel. Perhaps the owners of the building reaped what they sowed, for it was destroyed in the great fire of 1905.

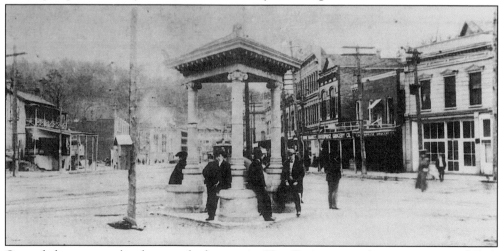

One of the commonly photographed spots in Hot Springs was the intersection of Park Avenue (coming in from the left in this c. 1900 photo), Whittington Avenue (on the right), and Central Avenue (laying directly south, behind the fountain in this photo). The newly completed fountain was dedicated during an 1899 celebration in honor of Admiral Dewey, a hero of the Spanish-American War. For much of the century, there has been some sort of fountain in the center of the intersection. Over the years horses, fine coaches, streetcars, and later automobiles made their way around the fountain, en route to hotels, bath houses, and such Whittington Avenue attractions as the Alligator Farm. (Courtesy of Arkansas History Commission.)

As the decade of the 1890s began, the quality of the Spa City's bath houses improved, as did that of its hotels. The striking Turkish-style Alhambra Bath House was erected in 1890 at 214 Ouachita Avenue. With its furnishings of oriental design, it was among the finest in the city. Sadly, this wonderful building was destroyed in the great fire of 1905, which wiped out some 40 blocks of the city.

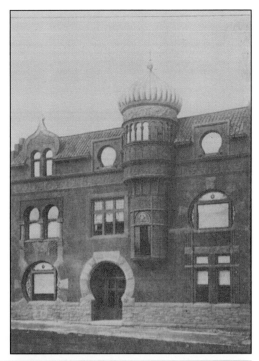

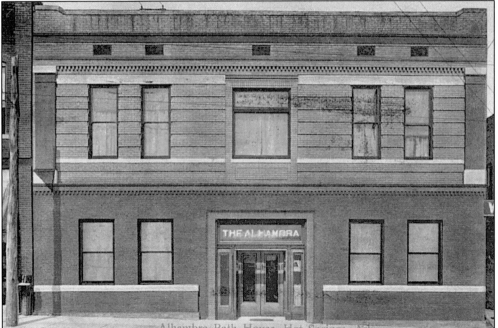

The Alhambra was quickly rebuilt on the same spot after the fire but in a much more conservative style, perhaps indicative of the difference in eras 15 years apart. The bath house operated for more than 50 years, popular with those at nearby budget level hotels; the cost of a bath was listed in a 1915 publication as 40¢. The beleaguered sender of this card wrote in 1908, "Had a trip with many break downs, however reached here at last." The Alhambra is gone today, and the site is a vacant lot.

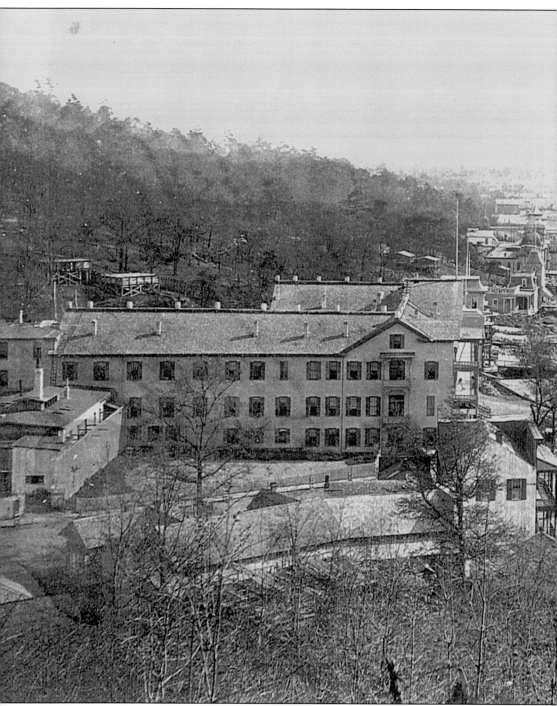

By the late 1880s the hotels and bath houses of Hot Springs were growing larger and grander as increasing numbers of visitors came from around the nation to partake of the fabled hot waters. Central Avenue is seen here, looking south from the intersection of Park and Whittington Avenues. The street was still dirt, and Hot Springs Creek, seen to the left of the avenue, was still an open ditch that would be encased within the next decade allowing construction of the

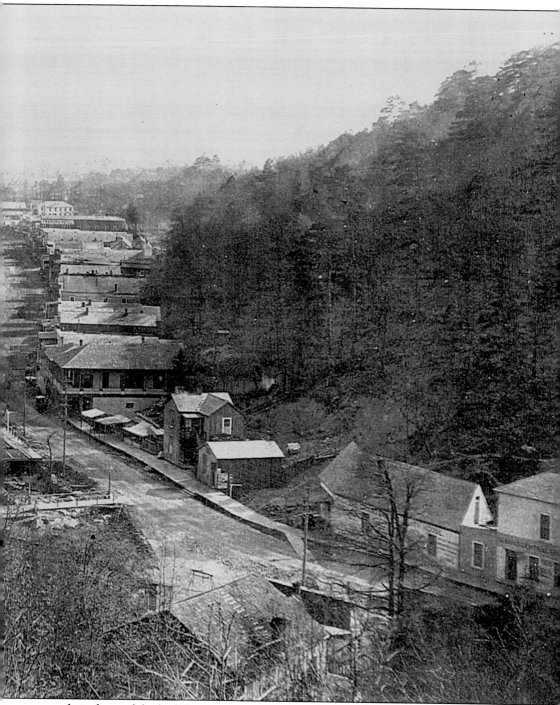

promenade in front of the bath houses. The large three-story building in the left foreground is the first Arlington Hotel, which had been completed in 1875. Further down the developing row the Palace, Maurice, and Hale Bath Houses are visible. Virtually every structure in this photo is gone today, some destroyed by fire and others razed by men ever intent on replacing the old with the new. (Courtesy of Bob Bethurem of Searcy, AR.)

The distinctive roof of the Palace Bath House is shown above around 1895. The wooden frame Palace, erected around 1880 by Samuel Fordyce and Charles Maurice, contained luxurious private bath rooms, marble "vapor, German, needle and shower baths," four parlors, and a large gymnasium. The water for the bath house flowed directly from a spring beneath the building. "Hello! This is the Place for 'FUN,' and great excitement" was the note penned in 1905 on the front of a card (below) of the grand entrance to the government reservation. The drive led between the Maurice Bath House on the left and the Palace Bath House on the right, both built *c*. 1880. The entrance opened onto twin stone staircases leading to a marble Greek-styled bandstand on the hillside and a series of mountain trails.

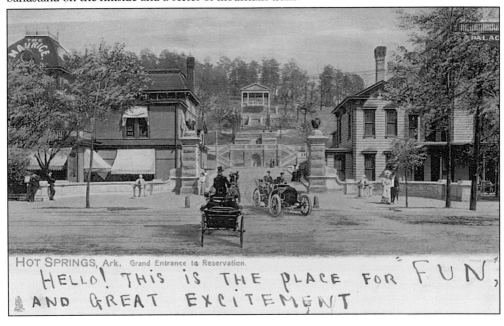

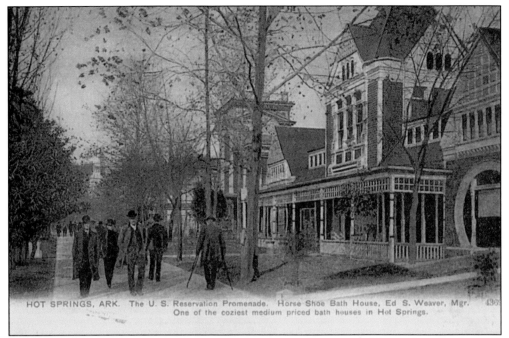

Just south of the Palace Bath House, behind the trees in the center of the card, is the elegantly trimmed Horseshoe Bath House. The building's name derived from its horseshoe-shaped windows, one of which is visible to the right. The building's porch offered a place to sit and rock after finishing a bath, perhaps to watch people like the man on crutches in this view, hobbling up the Promenade. The Horseshoe, where a bath could be had for 30¢ in 1910, was built in the 1880s and replaced in 1922 by the Quapaw Bath House.

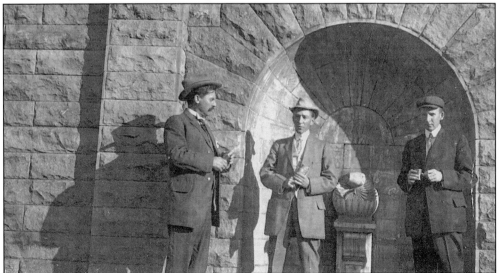

"This is me at one of the fountains of youth" was penned on the back of this 1910 card. The fountain behind the men was located at the end of the drive visible at the bottom of the preceding page. The men are holding folding metal drinking cups, a fixture carried by many of the tourists who strolled bath house row. Although the Grecian bandstand that towers above the men is gone today, the fountain and stone arch are still there.

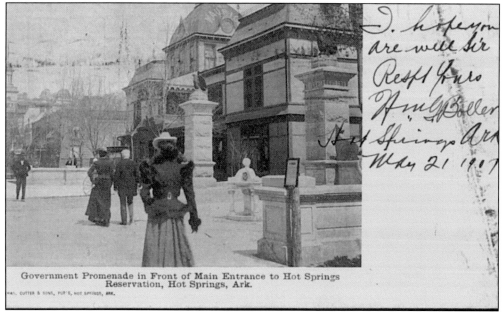

I hope you
are well sir
Respt yours
HmGBoller
Hot Springs Ark
May 21 1907

Government Promenade in Front of Main Entrance to Hot Springs
Reservation, Hot Springs, Ark.

HAL CUTTER & SONS, PUB'S, HOT SPRINGS, ARK.

A very popular spot for postcard photos was the Government Promenade, a wide walk that ran over Hot Springs Creek. Here, strollers at all hours could be seen walking past the row of bath houses. Shown in both of these cards is the Maurice Bath House (also visible to the left of the card at the bottom of page 22). Around 1890, W.G. Maurice purchased the Independent Bath House, which had catered to black patrons in then-segregated America. Maurice remodeled the bath house and renamed it the Maurice, reserving it then for a white-only clientele. Perhaps this societal reality was on the mind of the black woman bundled in her coat to the left in the card below, or of the black man holding the hand of a small boy as they were photographed looking at the Maurice. Both cards appeared c. 1900.

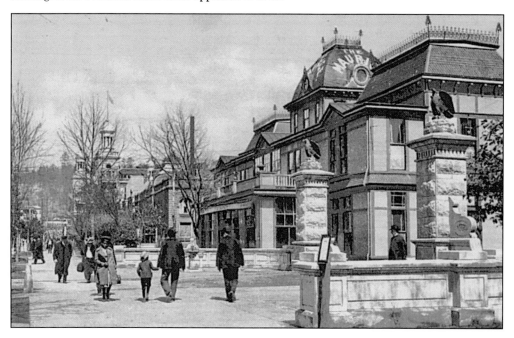

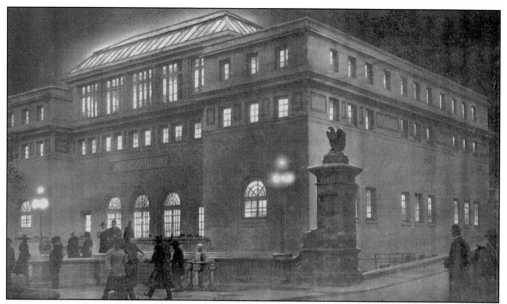

W.G. Maurice, determined to have the finest bath house in town, razed the old Maurice and opened a new one in 1912, seen above illuminated at night around 1915. In a setting filled with marble, stained glass, and the finest of equipment, a bath at the new Maurice rivaled the experience found in any spa in the world at the time. A booklet around the time of its opening noted the "European custom" of separating the bathing room from the bath lounge so that "You are not inhaling the exhalations of hundreds of sick patients taking baths, as is the case where you bathe and sweat in the same room." This arrangement of the "bathing department" and the "bath lounge" is seen in the card below, which also features the billard room. The Maurice Spring at the rear of the building supplied all of its water. The published price for bathing in the new house was $13 for a course of 21 baths, which included an attendant. Manager Harry Bell stated in advertising, "We are never crowded, as our capacity is one thousand baths daily. See the Maurice before you buy a bath ticket."

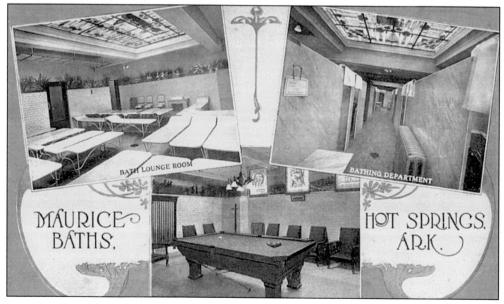

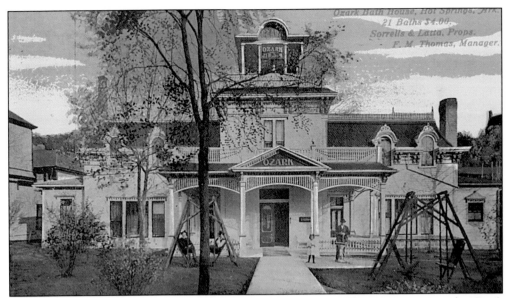

Moving on south down the promenade below the Maurice, strollers soon came to the Ozark Bath House, another of the Victorian-era frame structures that were erected beginning in the 1880s. The management of the Ozark advertised that "special attention is given to ladies and children," (hence the swing sets on the lawn) and that "all the lavatories are supplied with the latest automatic disinfecting machines." On the lower end of the cost spectrum, the Ozark advertised a course of 21 baths for $4. The house was razed and replaced in 1922 with a white stucco Ozark Bath House that still stands, though empty.

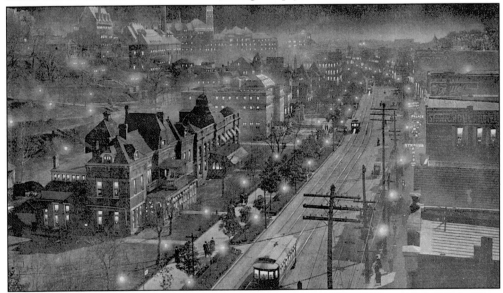

Around 1915, the Bluff City Engraving Company put out a small booklet entitled, "Night Time Views of Hot Springs, Ark." In actuality the photos were very artfully altered daytime views, in an era before cameras could capture high-resolution nighttime images. This photo, taken from atop a building across Central Avenue, shows the view south toward the Superior Bath House, the Hale, the Maurice, and all of the famous row. Towering in the background, with its observation tower light a shining beacon, is the 500-room Eastman Hotel.

W.G. Maurice's opening of his new bath house in 1912 came exactly one month before that of the Buckstaff, which had been built at a cost of $125,000. The Corinthian-styled bath palace was the most imposing structure on the row; it is seen below nestled between the c. 1880 Ozark and Magnesia Bath Houses. Perched on the hillside above the Buckstaff was the Army & Navy Hospital. One booklet published by the Buckstaff called it, "a beautiful creation of marble and stone, pressed brick, cement and exquisite fairness . . . It breaths sanitary beauty . . . It is designed to delight the eye and inspire the mind with lofty feelings and fill the heart of the yearning invalid with rich hopes of health and restored vitality." For years, one of the facility's most repeated claims was that "the entire force of the Buckstaff is composed of experienced WHITE persons."

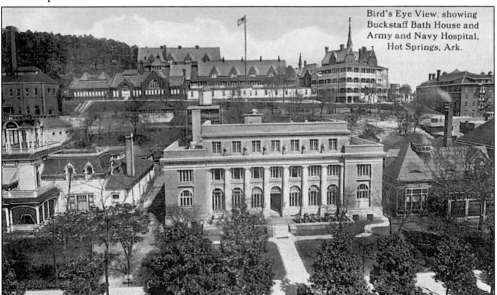

Bird's Eye View, showing Buckstaff Bath House and Army and Navy Hospital, Hot Springs, Ark.

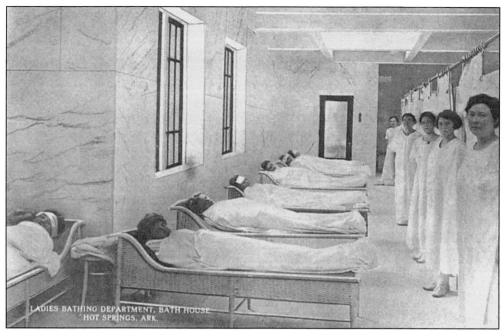

The Buckstaff catered to both men and women in the luxury of marble appointments and the latest equipment. Seen above are female patrons wrapped in towels relaxing after their baths; posed in front of them are their individual attendants. The entire second floor was devoted to serving women, who were drawn by such features as "luxurious rest rooms which seem more like the elegant drawing room of a high class hotel." The entire first floor was reserved for men, a group of which are seen below in the hot pack and steam room. In a reference to the Prohibition Era, the c. 1920 card joked, "Whiskey is subtracted here mathematically."

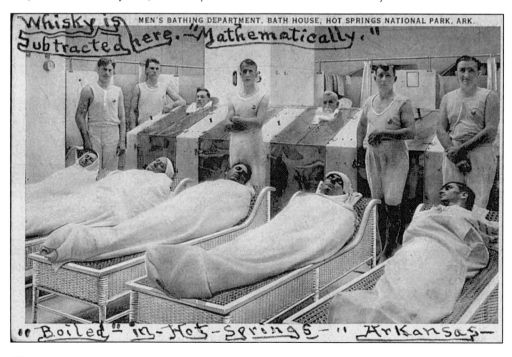

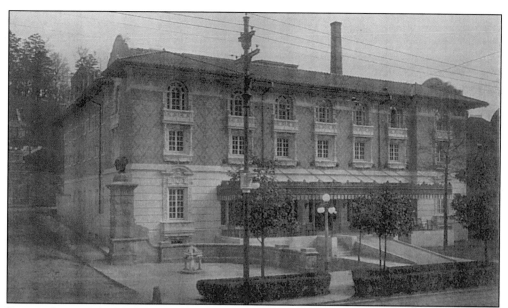

During the years between 1900 and World War I, a contest of "one upsmanship" seemed to prevail, as first one and then another owner tried to erect the grandest bath house in the city. While the Maurice and the Buckstaff dueled for preeminence, Union Army veteran and railroad baron Colonel Samuel Fordyce moved with a $200,000 investment to take the title. When the Fordyce Bath House opened on the site of the old Palace Bath House in 1915, the Spanish Renaissance-style building boasted the latest features available. A booklet on the Fordyce at the time of its opening stated, "No money or skill has been spared to make this establishment the most practical, complete and luxurious bath house in the world." In addition to a library, the largest gymnasium in the city, a roof garden, and two bowling alleys, the Fordyce paid special attention to the ladies by providing a combination sun parlor, music chamber, and reading room. It is seen in this postcard around 1920.

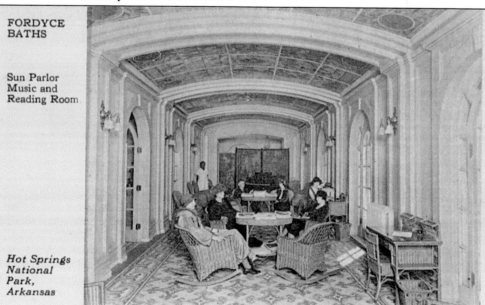

FORDYCE
BATHS

Sun Parlor
Music and
Reading Room

Hot Springs
National
Park,
Arkansas

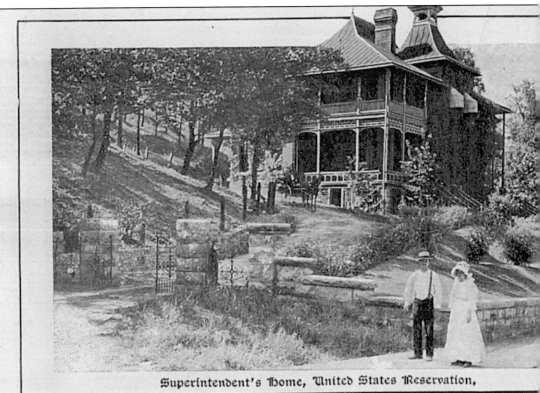

Superintendent's Home, United States Reservation,

The Superintendent of the U.S. Reservation was furnished with a large home on Fountain Street, seen here in 1900. The stately home survived until it was razed in 1958. Seen down the

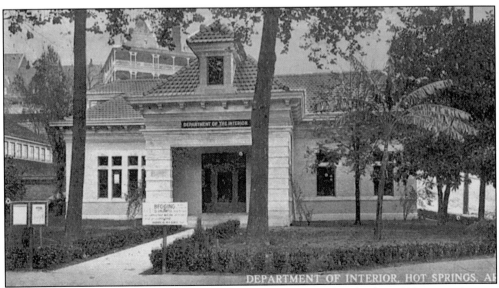

The office of the U.S. Reservation, and of Hot Springs National Park after 1922, is seen here at Central and Reservation Avenues. Towering behind the building is the Army & Navy Hospital. "I am getting along fine, pains have all left me," reads the penciled message on the card mailed to Illinois is 1917. The building was torn down in 1935 and replaced by another headquarters.

West Mountain.

street to the right, at the intersection with Central Avenue, is Hot Springs Bath House.

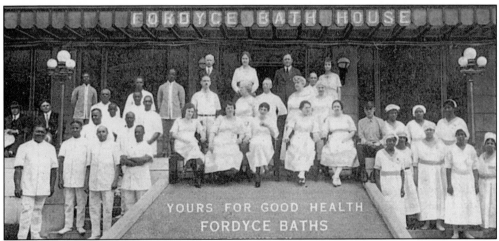

FORDYCE BATH HOUSE

YOURS FOR GOOD HEALTH
FORDYCE BATHS

"Rivaling in magnificence the Roman Baths of old," proclaimed the message on the back of this c. 1915 card of the Fordyce Bath House. In front of the establishment posed the staff, largely composed of bath attendants. Decades before the national discussion on handicapped access issues, the Fordyce entrance was fronted with a wide ramp for the benefit of the infirm seeking health in the baths. Today, the ramped entrance has been replaced by steps leading into the wonderfully restored Fordyce, where visitors are greeted by National Park Service rangers. The Fordyce is the present-day Visitors Center for Hot Springs National Park.

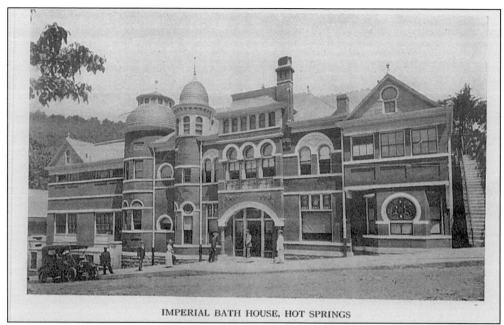

IMPERIAL BATH HOUSE, HOT SPRINGS

Located beside the Park Service headquarters was the Imperial Bath House. Erected in 1893, it was one of the more ornate buildings in Hot Springs. The Imperial was located on Reservation Avenue just off Central, and anchored the lower end of Bath House Row for decades before falling to the wrecking ball in 1937. It is seen here around 1910.

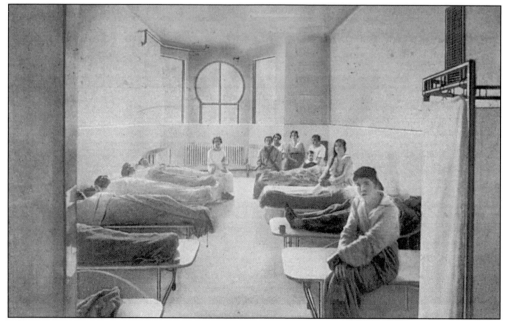

"We are enjoying our baths and wish you were here," was the 1929 message on a card of the women's hot pack room at the Imperial. Located across from the massive 500-room Eastman Hotel, the Imperial marketed heavily to women. One 1917 brochure stated, "Dressing rooms for ladies are equipped with a mirror, plate glass shelf, sanitary chair, hat and clothes hooks;" "The tubs are solid porcelain;" and "individual dressing rooms are done entirely in marble."

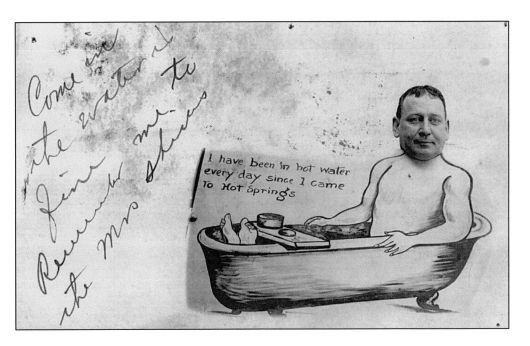

The two cards on this page are examples of both humorous and more solemn greetings sent from Hot Springs to the folks back home. The 1910 card above was sent to Los Angeles by a guest of the Rockafellow Hotel, presumably the man in the comic pose. The 1905 card below, sent two years before it was legal to write messages on the back of postcards, was much more telling about the nature of the thousands who visited the city. "Am very comfortably situated. Expect to remain balance of winter. The place is beautiful and visitors are here from the world over. Their ailments are principally rheumatism, but other diseases are also well represented. A great many are here for recreation only." The visitor was from Massachusetts; the postcard she selected to send shows a path on Hot Springs Mountain.

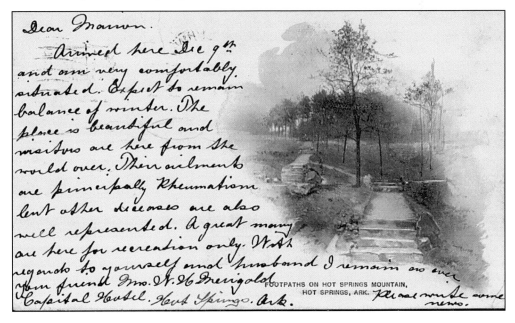

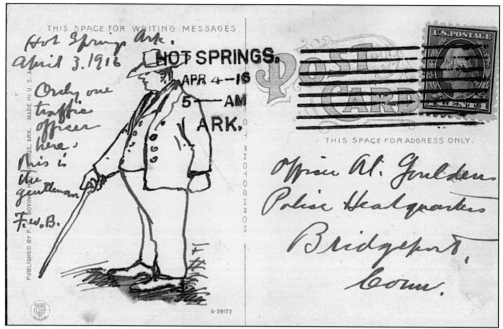

The coming of increasing railroad activity brought thousands of added visitors to stroll the streets and paths of Hot Springs. One of these visitors sent this card, drawing on the back a picture and penned, "Only traffic officer here, this is the gentleman." At the time, traffic on Central Avenue would have included rumbling streetcars, automobiles, wagons, and many pedestrians crossing back and forth on the bustling avenue.

Opposite page: Although Hot Springs had obtained rail service in the 1890s from the directions east and north, the city fathers very much wanted good connections to the west in order to attract the most visitors and commerce. On St. Patrick's Day, March 17, 1914, that goal was realized when the town turned out to welcome the first train of the newly created Memphis Dallas & Gulf Railroad, a venture of local businessmen. The railroad was not destined to have a long life, however; during World War I the federal government took control of the state's major railroad, the Missouri Pacific, but passed over the upstart line. By the time the war was over the railroad was in financial trouble and never recovered, finally ceasing operation altogether in the mid-1920s. (Photos courtesy of Bob Carnation of Little Rock.)

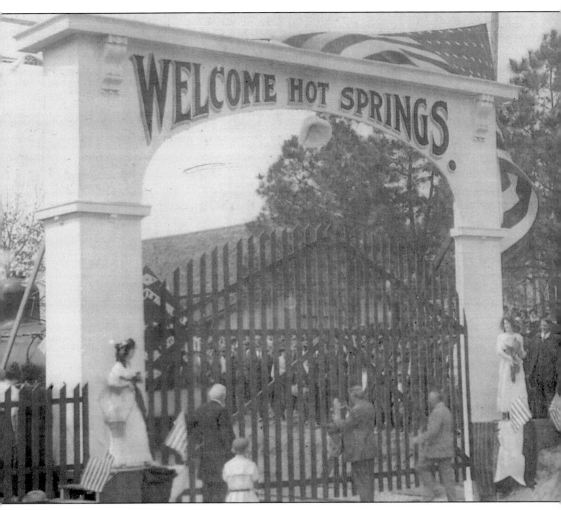

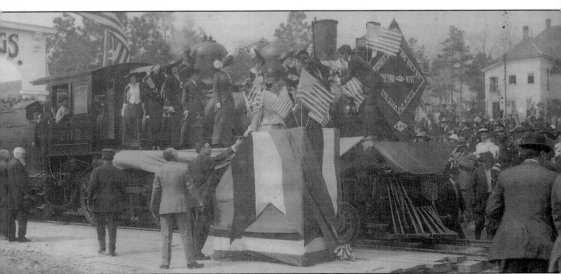

35

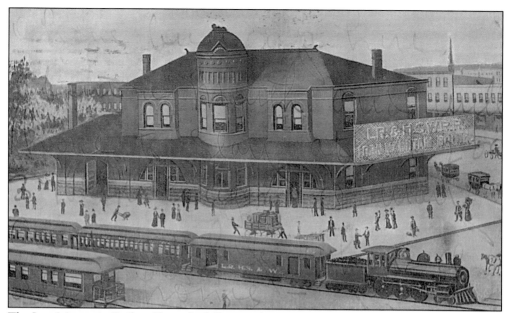

The Iron Mountain Railroad brought full-size rail service to Hot Springs in the 1890s, breaking the monopoly of the narrow-gauge Diamond Joe Line. Merging with the Missouri Pacific early in the 20th century, the railroad's depot on Malvern Avenue was the point of arrival and departure for thousands of visitors to the Spa City for two decades. Tragedy struck in September of 1913 when a fire broke out in a cottage near the depot; the resulting blaze was the worst in the city's history, consuming 50 square blocks. Seen to the left in the lower photo is the depot, with smoke pouring out of its round tower. The depot was a total loss, as was the pool hall and the water tower, visible across Malvern Avenue to the right. The depot was rebuilt, but not as imposing, and still stands, but the last passenger train to Hot Springs pulled out in 1964. (Photo courtesy of Arkansas History Commission.)

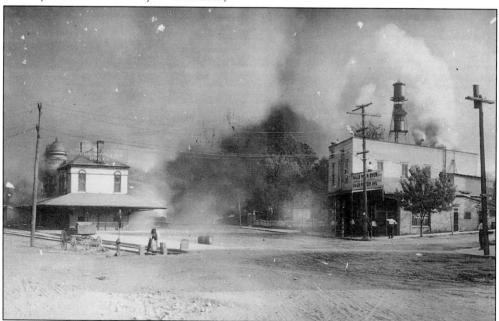

Two

CENTRAL AVENUE
COMMERCE AND
DISASTERS

While the bath house development was almost all lined along the eastern side of Central Avenue, on the opposite side an incredible array of commercial activity developed over a dozen blocks. Found at either end of the strip were grand hotels, placed intermittently between dozens of small hotels, and boarding houses, some above quaint shops, others on side streets.

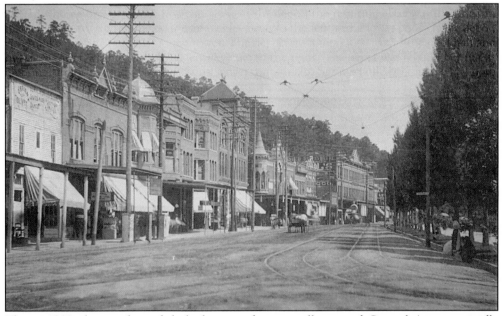

This c. 1900 photo, taken while looking north on a still-unpaved Central Avenue, vividly shows the distinct differences in how the two sides of the street developed. On the right is the tree-lined walk that passes by a dozen bath houses; on the left are blocks of tightly packed shops and hotels. Visible at the far left is one of the few remaining wood-sided shops, most likely from the 1870s, housing O'Brien & Olivey's men's clothing shop. The taller, peaked building in the center of photo is the Pullman Hotel; just beyond it is Sorrells Drug Store, and in the far distance is the Palace Hotel. (Photo courtesy of Arkansas History Commission.)

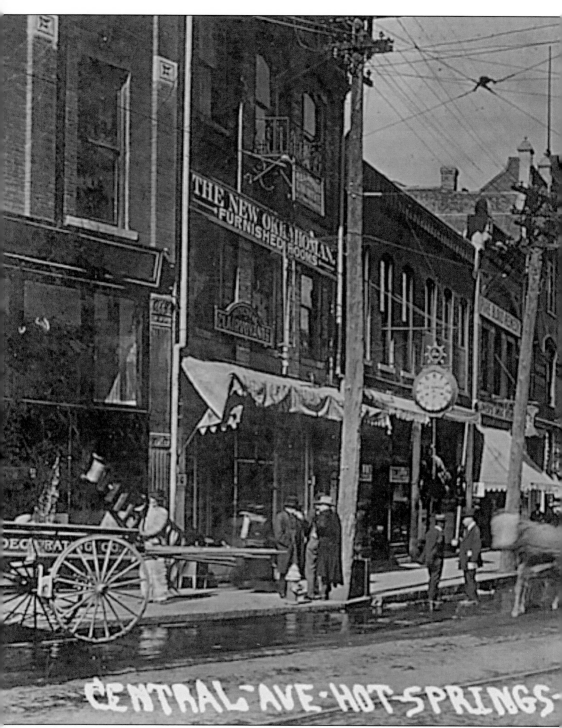

CENTRAL·AVE·HOT·SPRINGS·

Around 1905, shortly before automobiles arrived, Central Avenue, looking north from its intersection with Bridge Street, was a hub of activity. A decorator's wagon is parked to the left, while a briskly moving buggy passes in front of the New Oklahoman rooming house. Also operating in this area was a clairvoyant, and a drug store advertising a "pure blood remedy."

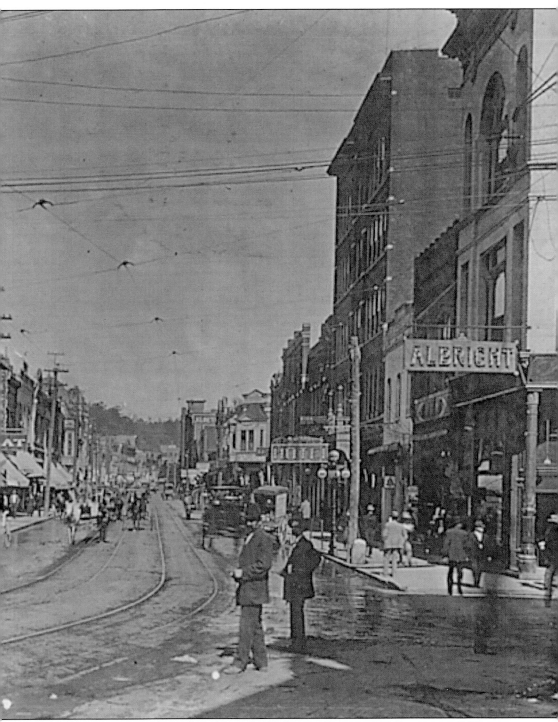

The large T.E. Towell clock, in the shape of a pocket watch, recorded the time as 8:20 a.m. (although at the time many such clocks were not functional, but merely decorative). This same area can be seen on p. 58 in a view five years later, with flood waters filling the street.

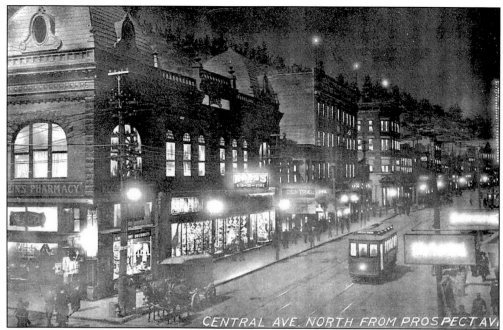

Seen in these two views is the difference in night and day, but also in the progress of perhaps ten years on a block of Central looking north from Prospect Avenue. Prominent to the left (in the nighttime view) is the Klein Drug Store around 1905, and next to it is the Kress store. Just beyond is the lighted marquee of the Central Theater and then the Hotel Central, erected in 1904. As streetcars passed, strollers window shopped at Kress or went into Klein's for a soda at the fountain. By around 1915 (below), changes were coming with automobiles starting to crowd the wagons and streetcars. Klein's, formerly operated by pharmacist George Klein, had become Schneck's Pharmacy, but Kress and the Central Theater still held their spots. Across the street to the right is the White Star Restaurant and another small hotel. Though vacant today, the Hotel Central still stands; however, a number of the other buildings visible here are now gone.

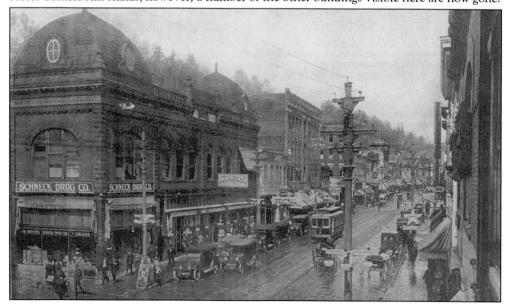

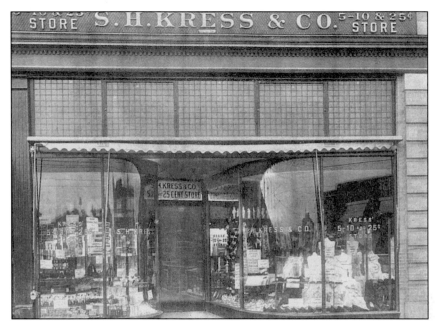

Although it would later relocate a few blocks down, the S.H. Kress store was an institution on Central Avenue for more than eight decades, before succumbing to the shopping center shift in 1985. Over the years the "5-10 & 25 Cent Store" catered to countless tourists, and surely sold thousands of postcards of the resort city.

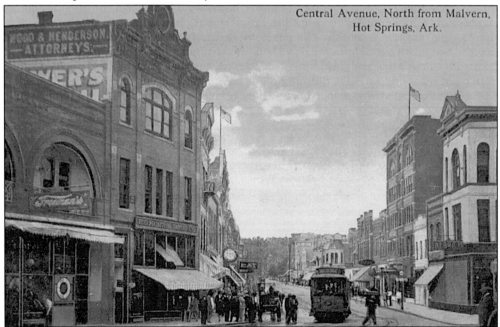

Central Avenue, North from Malvern, Hot Springs, Ark.

This view looks north from the intersection of Malvern Avenue and Central, the tall building to the left housing Morris Drug Store at 802 Central. Morris Drug operated at this location until closing in 1971. Housed for a time in the upper floor of the building was the Improved Order of Red Men, a men's fraternal organization. The building survived various fires over the years, and so much remodeling that it bears almost no resemblance today to this *c.* 1910 image.

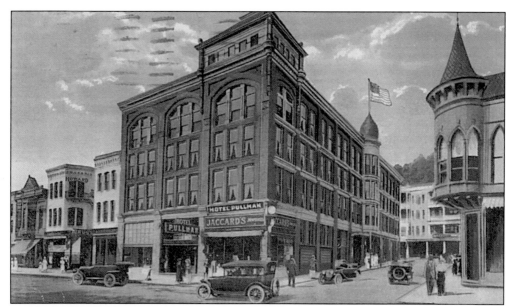

Anchoring the north end of the 400 block of Central for decades was the Hotel Pullman, one of the more popular budget hotels in the city. By the time of this 1920 card, the lower level of the hotel was home to Jaccard's Jewelry store. The Pullman advertised itself as the "best hotel in Hot Springs outside the Big Four"—meaning the Arlington, the Majestic, the Park, and the Eastman. The hotel, with an advertised capacity of 100 and room rates from $2 to $3 a day, has been gone for many years. Located to the left at 334 Central is Sorrells Drug Store, its ornate facade prominent in the photo on p. 44.

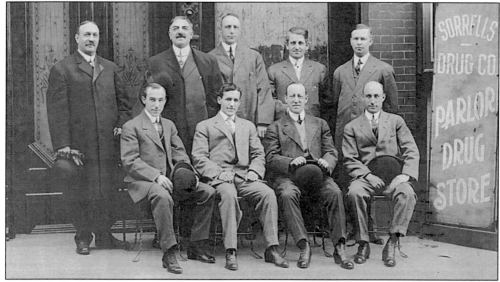

Sorrells Drug Store was a popular stop for tourists from its opening in 1896; it sold among other items a line of robes to be used at the bath houses. W.S. Sorrell was also the co-owner of the Ozark Bath House located across the street. In 1910 this group posed in front of the store, penning a message back to Peoria, IL, that read, "Our gang of mountain climbers." Like the group of men, Sorrells and its wonderful building are long gone, having burned in 1928; the site is a parking lot today.

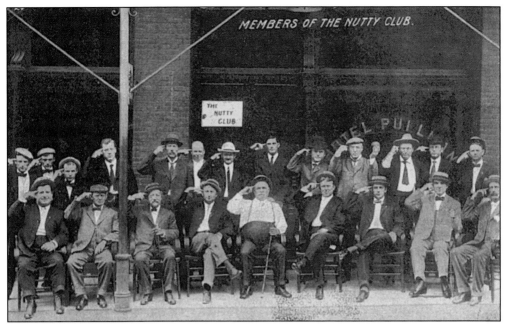

These well-dressed gentlemen, each with a finger pointing to his head in the comical affirmation of their mental state, were members of the "Nutty Club," which apparently met at the Hotel Pullman. The club members posed for at least two different postcards; the organization's purpose or the meaning of its name is lost in history.

A stroller might have stopped into Gem Optical at 712 Central around 1910 to be fitted for a new pair of eyeglasses. By 1912 the building housed the Gem Jewelry Company.

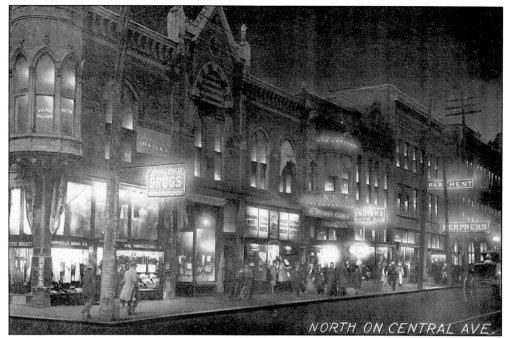

NORTH ON CENTRAL AVE.

A nighttime view of the 400 block of Central shows crowded sidewalks, with the windows of Sorrells Drug Store well lit. Above the store is the office of a Dr. Williams. Beyond the drug store is a men's clothing store; next down is the Indiana Club and Bar, which was a notorious gambling club; Kempner's Department Store is just beyond. Most of this block was destroyed in a 1928 fire.

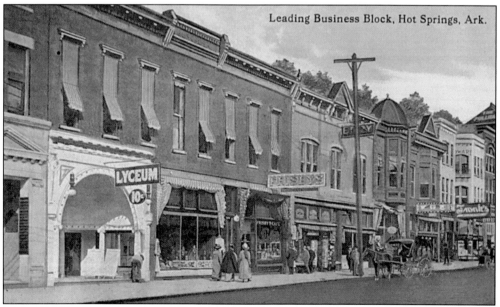

Leading Business Block, Hot Springs, Ark.

In the 500 block of Central visitors found both the Lyceum theater, which offered silent films for a dime a ticket, and Frisby's Cafe, one of the most popular eateries in town. At the far right side of the view is the Hotel Pullman, seen on p. 42, which placed its guests within a short walk of a night of dining and entertainment.

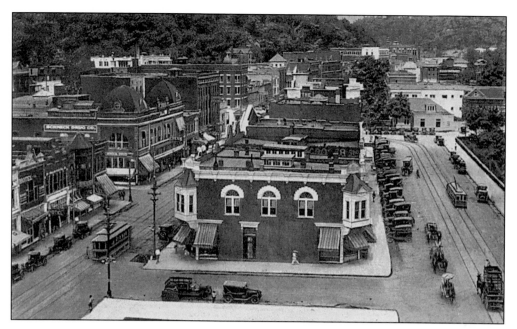

Pictured in both of these c. 1915 cards is one of most thriving commercial blocks in early-20th-century Hot Springs. In the view above, taken from atop Citizens Bank, the 600 block of Central is visible to the left with Valley Street on the right. Bars, cafes, and other businesses faced out onto both streets. In the card below the Central side of the same block is seen, in a view taken from atop the Woolworth's Store across the street. On the corner is D.C. Richards Store, which advertised pianos, Victrolas, typewriters, and sewing machines. Further down is the Greek Revival-style building of the Arkansas Trust Company. Rising in the background is one end of the Eastman Hotel, facing Valley Street. This entire block of wonderful buildings was torn down in the 1980s; the site today is a small park.

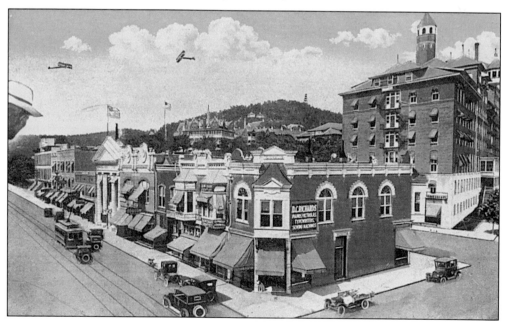

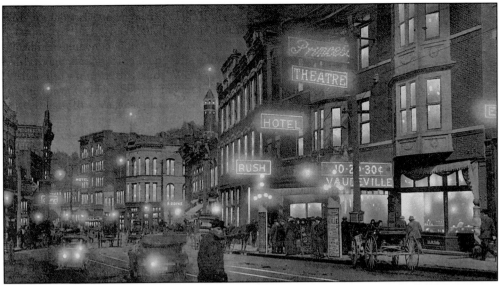

By night or day, there was much to see and do on Central Avenue for visitors seeking amusement between baths. In the c. 1910 nighttime view above, the photographer looked north toward the Princess Theater. Mr. Frank Head, who had managed the Opera House shown on p. 16, yielded to the future of entertainment and built the Princess in 1910 to showcase both vaudeville acts and the growing number of silent films coming out of Hollywood. The first time a movie with sound played in Hot Springs was in 1929; the theater burned in 1935, and the Malco Theater was built on the site. Further up the street glowed the arched windows of the Marquette Hotel. In the card below, the same view is seen around World War I, a block further south on Central, from the intersection with Ouachita Avenue. To the left is the Goddard Hotel, which took up much of the 800 block; the corner shop featuring cigars was the Chicago Cigar Store and News Stand. The tall white building next door to the Princess had not yet been built at the time of the above photo; it is the Citizens National Bank.

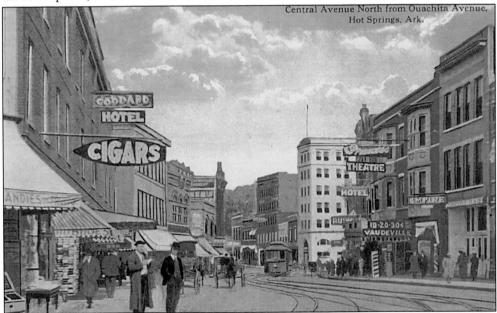

Central Avenue North from Ouachita Avenue, Hot Springs, Ark.

"My room" was marked on a card of the Marquette Hotel, which billed itself as the "leading commercial hotel of the city," with room rates at "$1 and up." The c. 1915 visitor also wrote on this card, "Went up to the tower (on Hot Springs mountain). Sweetheart, this is a great place to see these springs coming out of the mountains so hot. 135 Degrees—that is pretty hot."

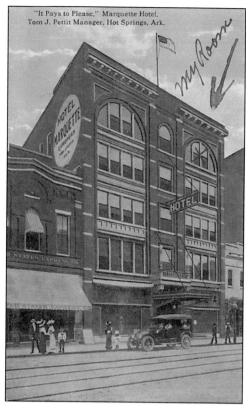

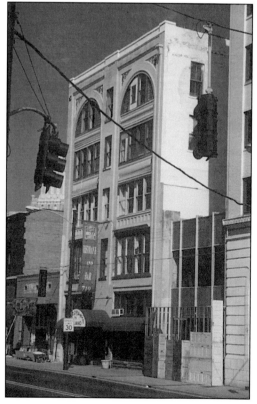

The Marquette, even though heavily damaged by fire in 1923, operated as a hotel at 719 Central Avenue for more than 50 years. Unlike many of Hot Springs' hotels of the era, however, the Marquette survives; the lower portion today houses the Belle Arti Ristorante and Bar, one of the finest dining establishments in the city. (Photo by Ray Hanley, 2000.)

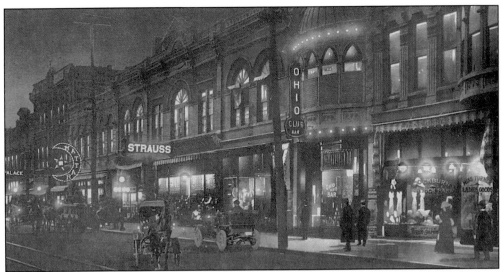

A popular spot after dark in Hot Springs was the Ohio Club, which opened in 1905. Its long mahogany bar often provided standing room only due to the many patrons, until Prohibition came in 1915 and forced the Ohio to convert to a cigar store. Next to it are the offices and a retail outlet for Cockburn's Ostrich Farm, which was located on Whittington Avenue. Window shoppers were drawn to Mattar's Oriental Palace of Art, and the clothing store of Herman and Gus Strauss to the left. A 1903 city directory described the Strauss establishment as "clothiers, haberdashers and dealers in men's correct wear bathing outfits." Gus Strauss also served as president of Citizens Bank for many years. This image appeared c. 1910.

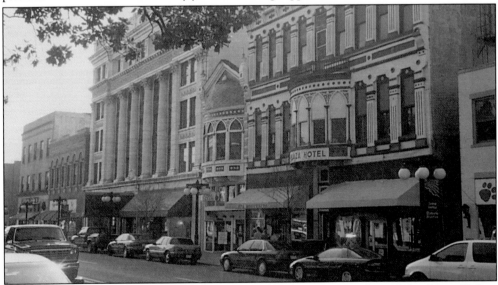

One of the most successful preservation stories in Hot Springs is that of the Ohio Club—however, the club is closed today after a fire, the building vacant. The columned building to the left is the Thompson Building, which was erected in 1913. The finest office building in the city at the time, it was designed by architect George Mann, who had only recently served as the leading designer for the new state capitol. The space that once housed the offices of Cockburn's Ostrich Farm and Miss Turner's Ladies Goods is today home to Spa Souvenirs. (Photo by Ray Hanley, 2000.)

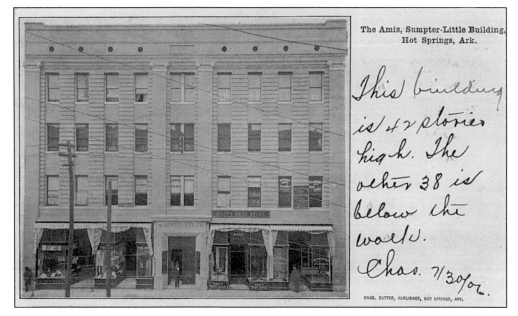

The Amis, Sumpter-Little Building, Hot Springs, Ark.

This building is 42 stories high. The other 38 is below the walk. Chas. 7/30/06.

CHAS. CUTTER, PUBLISHER, HOT SPRINGS, ARK.

Adjacent buildings in the 600 block of Central included the Amis, Sumpter-Little Building, seen in the card above, and the Security Bank, seen below. The 1906 message on the card above read, "This building is 42 stories high. The other 38 is below the walk." This was not true of course, but the building did house a drug store and offices; later it became the Hotel Central. It stands vacant today, awaiting restoration. The Security Bank, seen below around 1920, resembled a vault itself, but it proved no match for the bank runs that helped launch the Great Depression, which closed it for good. Today, the building houses Angels, an Italian restaurant.

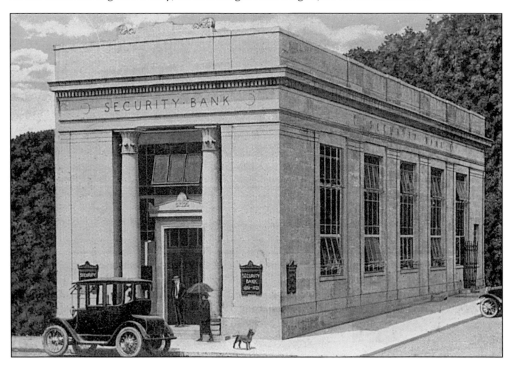

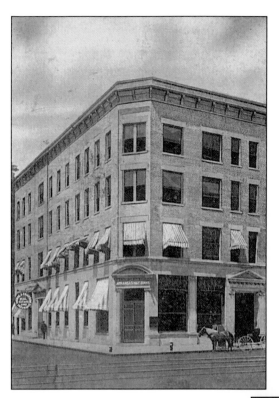

The Arkansas National Bank, founded in 1882, soon built this structure at the corner of Central and Court. It was torn down around 1970; the site is today home to a location of the Bank of America.

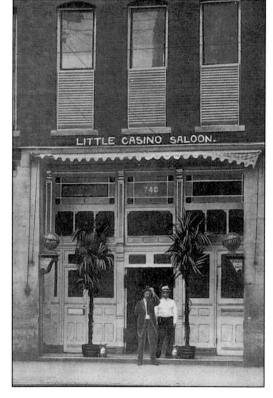

J.L. Brignardello was part of a family of Italian immigrants who made their home in Hot Springs; he made his living in the saloon business. Operating the Little Casino Saloon at 740 Central, Brignardello certainly served liquor; in an era when gambling was common, it was likely that gambling was taking place in his business as well. Today the site of the building is a parking lot.

50

S.M. Duffie & Company was located at 812 to 814 Central Avenue during the first few years of the 20th century. Operated by Samuel M. Duffie, the store advertised heavily. A 1903 ad for the store said, "When You've Got to Fit Your Liveliest Kid, Go to Duffie's, From the Shoes on His Feet to What He Calls His "Lid," Go to Duffie's—And He's Got It to Suit You, In Style and Effect, Be You Short and Well Rounded or Tall and Erect." Today the Townsend building, which once housed Duffie's, still has the name of the store painted on one end of the building.

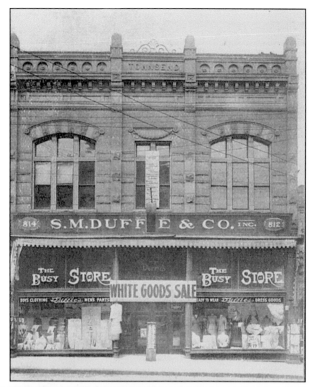

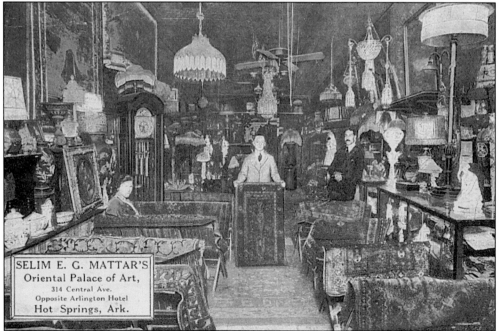

Selim Mattar and his brother Raeff operated their Oriental Palace of Fine Art at 314 Central. It was a business that moved several times, but was a part of the Spa City business community for decades. The Mattars were natives of Turkey, and their children continued to operate an import business, apartments, and an art gallery for many years after the death of the brothers.

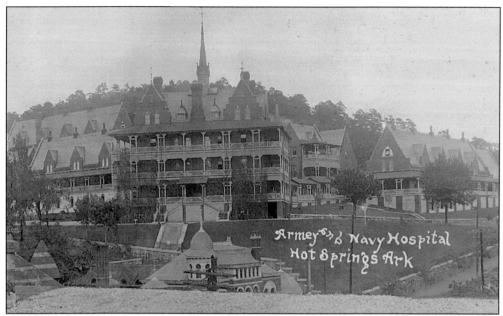

Visible from many vantage points, a looming presence over much of Central Avenue was the Army & Navy Hospital, opened in 1887 on 24 acres. Seen above in a 1908 card, the hospital towered over the Imperial Bath House. The effort to build the hospital came about when Dr. Algernon Garnett, a former Confederate surgeon, took note of the impoverished Civil War veterans among those flocking to Hot Springs seeking aid for old but still painful war wounds. Garnett enlisted the aid of former Union soldiers with means, including Samuel Fordyce, to push a bill through Congress to build the hospital. The c. 1910 card below was sent to Indiana by a patient at the Army & Navy. On it is written the following: "I am trying to write to all the girls while I am here. Am feeling better than when I first came." Stationed at the hospital over the years were many active-duty soldiers, some of whom posed on the steps in the view below. The inset shows patients in one of the hospital wards.

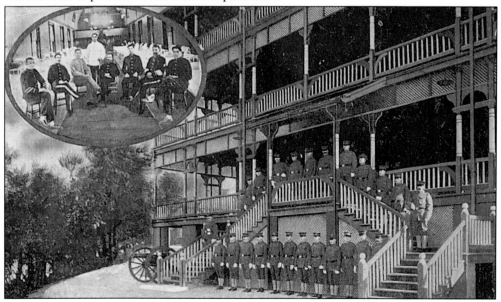

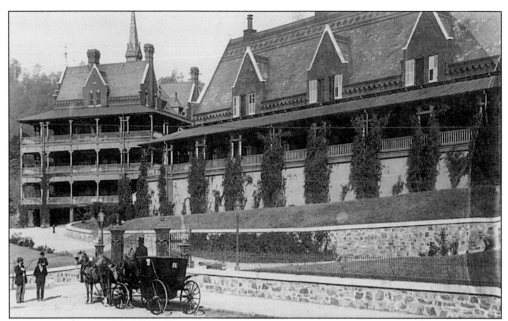

The Army & Navy Hospital's wrought-iron entrance gate was a popular stop for the carriages of those with business and those who simply came to gaze up at the hilltop buildings. Veterans from conflicts ranging from the Civil War to campaigns against western Indian tribes and the Spanish-American War had come to seek relief from disease and pain at the hospital by the time of the *c.* 1900 photo above. A 1910 pamphlet said of the facility, "It is one of the best hospitals in America, and receives retired and active soldiers and sailors of the army and navy. No hospital in the world records as many cures of its patients as this one, 95% of the soldiers and sailors here being returned to duty." Below is the gate on the back side of the hospital that led out to the drive along the side of Hot Springs Mountain, passing by the marble bandstand that looked down onto the bath houses of Central Avenue. The gate is still there today. (Photo courtesy of Arkansas History Commission.)

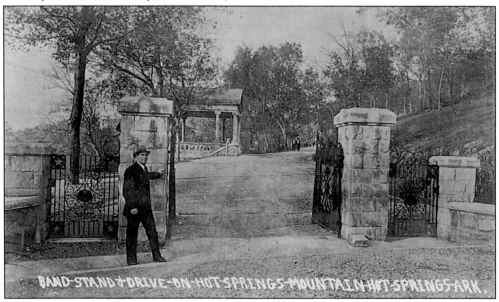

BAND-STAND & DRIVE-ON-HOT-SPRINGS-MOUNTAIN-HOT-SPRINGS-ARK.

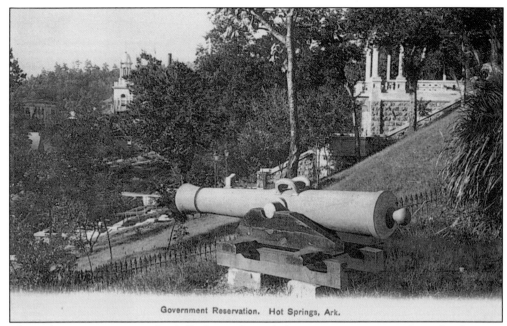

Government Reservation. Hot Springs, Ark.

The military presence on the hill above Central Avenue was apparent from the looming hospital, but was also seen in more subtle images. Here, where the hospital grounds met those of the park reservation, a Civil War–era naval cannon was mounted over the iron fence. To the right is the marble bandstand, while in the distance is one of the twin towers of the Arlington Hotel.

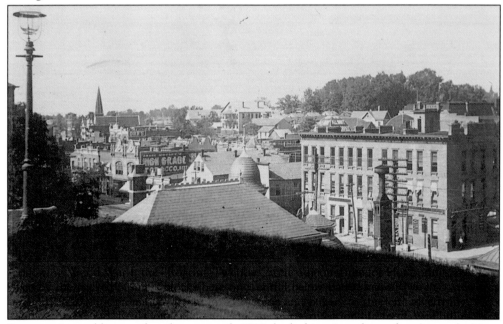

Recuperating soldiers and sailors around 1900 had this view from the Army & Navy Hospital's front lawn, looking out over the roof tops the southern part of Hot Springs. In the immediate foreground is the roof of the Imperial Bath House. (Photo courtesy of Arkansas History Commission.)

54

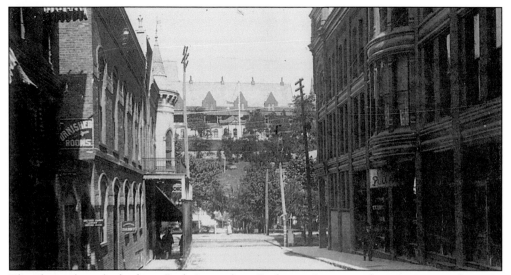

The photo above looks down Bath Street from Exchange Street, a side street running between the Pullman Hotel to the right and Sorrell's Drug Store to the left; both of these faced out onto Central Avenue, with the Army & Navy Hospital on the hillside across the street. The photo, taken from the front of the Milwaukee Hotel, offers a look at what a commanding presence the hospital would have had for patrons of either establishment. To the left a small sign offers furnished rooms, indicative of the budget accommodations scattered throughout Hot Springs. This photo appeared c. 1900. (Courtesy of Arkansas History Commission.)

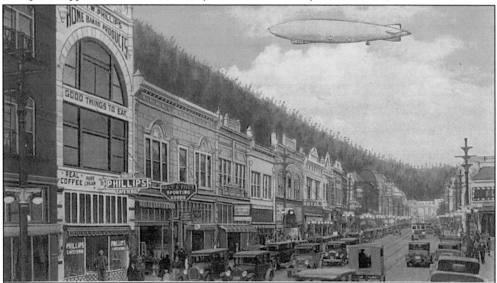

Following World War I, the "Roaring Twenties" were a boom time for Hot Springs, as can be seen by the packed business blocks here on Central below Bath House Row, in a view from around 1925. Most prominent is Phillip's Cafeteria and Bakery to the left, advertising "Good Things to Eat" and "Real Coffee, Pure Cream" under the direction of Mrs. T.W. Phillips. Next to it is a sporting goods store, and in the center of the block is the Royal Theater. The blimp floating overhead was added by of the postcard publisher, seeking to make this card stand apart on the drug store racks from its less-embellished competition. Such a ship did visit Hot Springs for a time.

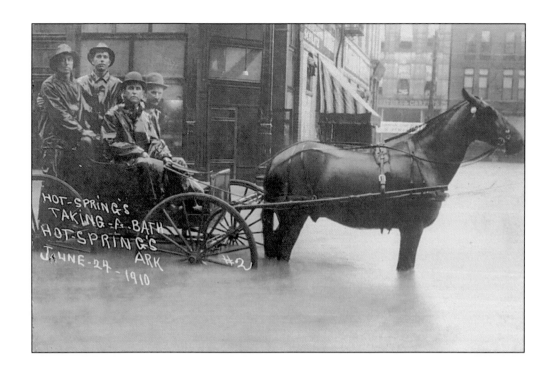

As beautiful as Central Avenue was in good weather, its narrow valley location could quickly turn against it on a whim of Mother Nature. A sudden thunderstorm on June 24, 1910, turned the broad avenue into a raging torrent. As with other disasters of the era, photographers were out taking photos before the rains had even stopped; the images were available within hours, and were often sent on postcards to friends and family.

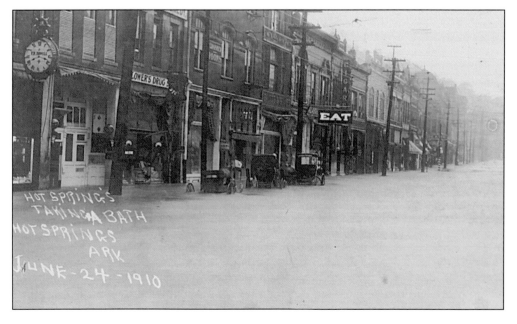

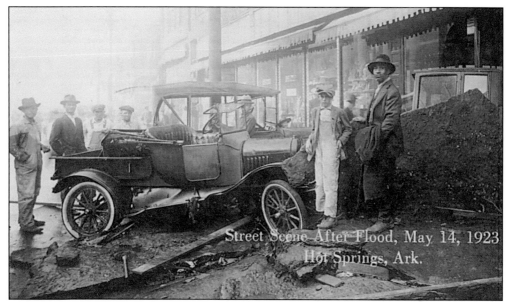

Street Scene After Flood, May 14, 1923
Hot Springs, Ark.

As bad as the flood of 1910 had been, the worst was yet to come. On May 14, 1923, Hot Springs was crippled by a flood. The headline the next day in the *Sentinel Daily Record* extra screamed, "FLOOD AND FIRE COUPLED IN GREAT DISASTER." "Flood and fire yesterday brought devastation in Hot Springs in greater proportions than this city, acquainted with big disasters, ever had met before . . . A stream of from 4 to 9 feet of water coursed madly through the valley. Upon its crest here and there were human forms. Hundreds of automobiles slipped and grated and then finally shot the waves. Many had occupants, frantic screaming women and little children." Seen above and below, after the flood waters subsided on Central, are images of buckled pavement and wrecked cars, some thrown through the windows of shops.

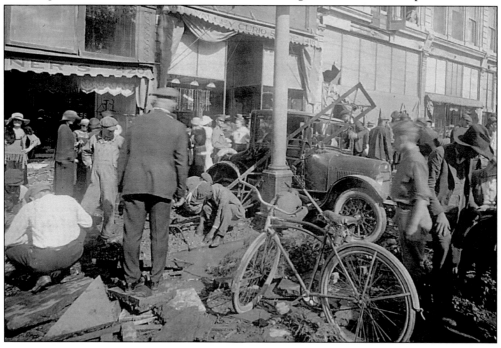

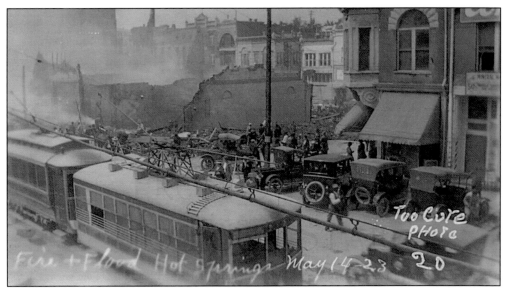

"Disastrous Fire In The Heart of the City," read the newspaper, for in the midst of the record flood a terrible fire broke out. Destroyed buildings included the Pythias Lodge and the American Express office. One news account read as follows: "In the darkness of the night, rendered more awesome through the suspension of electric light service, fire first met the view, revealing falling walls and crumbled automobiles stranded in the flood in front of doomed buildings. A raging river next came into view. The flood waters, lighted by the strange tinge thrown over them by the flames, presented a spectacular appearance as they swirled and roared their way through what was a few hours before a well kept, prosperous business thoroughfare." The view above looks across Valley Street toward Central Avenue. Streetcars halted with the loss of electrical power before burned-out buildings. The cleanup of Central Avenue started almost as soon as the flood waters drained off, with the assistance of the brigade of barefoot young boys seen below. The only confirmed death in the disaster was a young woman who drowned when her car was swept away; her escape was prevented when her long hair became entangled in the steering wheel.

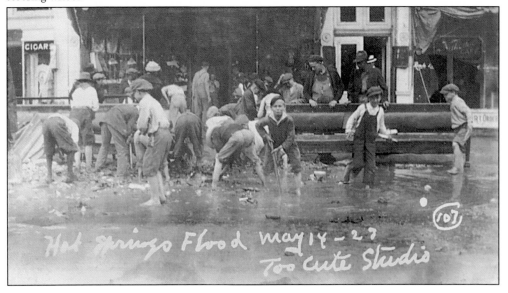

Three

LODGING:
FROM BUDGET
TO FOUR STAR

In describing the lodging choices of Hot Springs in 1894, one souvenir booklet stated, "One may be rich, and wish to surround himself with every luxury; or poor, but still desirous of all possible comfort; an invalid, in search of perfect quiet and careful attendance; or in robust health, and on pleasure bent, or of a retiring nature, seeking only for seclusion and rest," for in Hot Springs, "its five hundred hotels and boarding houses are of all grades and suitable for all sorts and conditions of men."

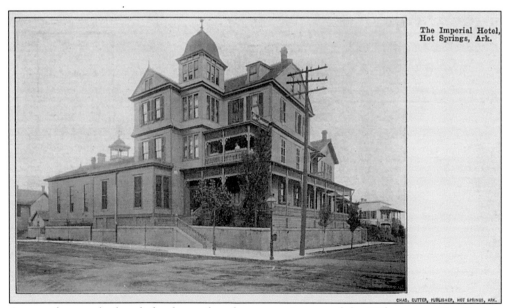

The Imperial Hotel, Hot Springs, Ark.

CHAS. CUTTER, PUBLISHER, HOT SPRINGS, ARK.

Among the popular hotels for those of modest means in turn-of-the-20th-century Hot Springs was the Imperial Hotel, located at the corner of Spring and Cottage Streets. Positioned a block from Central Avenue, near the depot and "fifty feet from the post office," the hotel had a published room rate of $1 per day in 1914, putting the establishment on the low end among hotels but slightly more expensive than most boardinghouses. Promoted features included "steam heat, electric lights, and hot and cold water." The Imperial was razed many years ago; the site is today home to the *Sentinel-Record* newspaper.

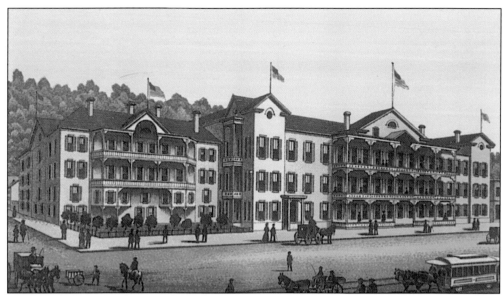

Throughout the resort history of Hot Springs the most spoken name in luxury accommodations was almost certainly the Arlington Hotel, at the southeast corner of Fountain and Central. The Arlington was completed in 1875 and, until the construction of the Eastman Hotel in 1890, it provided the finest lodging in the city. After the grand Eastman opened, however, the Arlington owners quickly moved to raise a new, more elegant Arlington to compete for the "carriage trade" among Hot Springs' visitors.

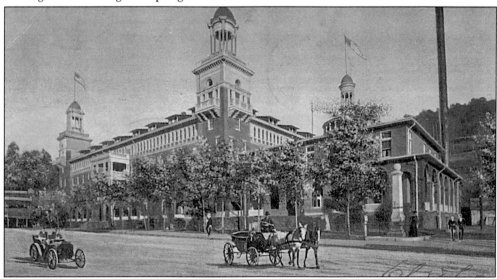

An 1894 tourist guidebook to Hot Springs said of the city's hotel options, "To the wealthy seeker, after either health or recreation, he who is able and willing to pay for the best of everything, the Eastman, the Park and the New Arlington offer accommodations not surpassed by any hotel in America." The 1893 opening of the "new" Spanish Renaissance-style Arlington on the site of the old served to keep the Arlington name at the forefront of hotel luxury in Hot Springs, at a cost of $550,000 to the Arlington Hotel Company. This postcard was printed in Germany around 1900, by "Raphael Tuck & Sons, Art Publishers to Their Majesties the King and Queen." It was not purchased and mailed until 1907.

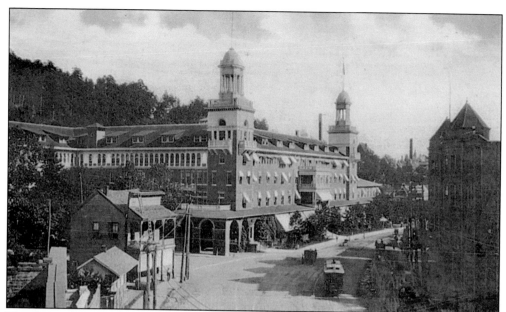

The above photo, looking south from Central Avenue, offers a contrast between the Arlington and its more modest neighboring buildings, mostly wooden structures remaining from the 1870s. At that time, the Arlington was the only hotel developed on reservation land owned by the federal government. It advertised the ability to accommodate 500 guests, with a listed price around 1910 of $4 to $8 per day; a course of 21 baths in the hotel's own bath house would have cost $10 at that time.

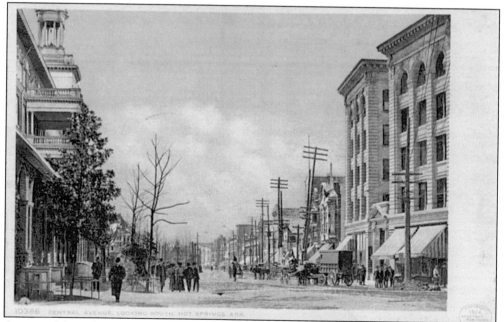

A guest of the Arlington was but a few yards from the bustling shops and services across Central Avenue, which was still unpaved at the time of this c. 1900 card. The delivery wagon to the right is parked in front of the Dugan-Stuart building. The structure's twin-splayed wings housed medical and other professional offices, and even a bowling alley on the ground floor.

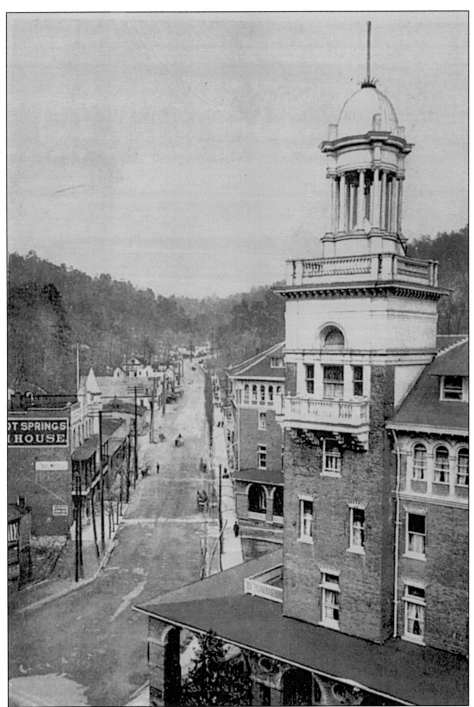

The Arlington's 25-foot-square twin observation towers rose 40 feet above the hotel's roof, affording striking views of the bustling city and the surrounding mountains. The tower pictured here, on the northwest corner of the hotel, offered a view up Fountain Street into the area known as Happy Hollow, which was home to a popular outdoor photo gallery. The small but ornate Hot Springs Bath House can be seen to the lower left.

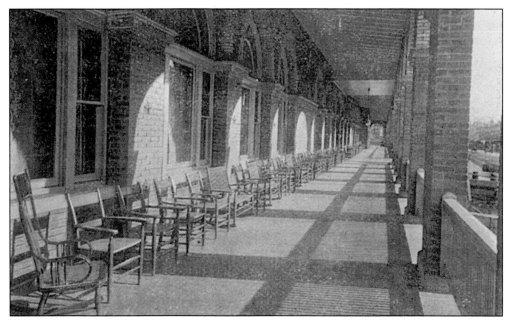

With some 300 rooms and a stated capacity for 500 guests at any one time, the Arlington saw many guests spending a part of each day seated in one of the chairs lining the 650-foot veranda that ran the length of its front. Seated on this porch, which spanned the length of two football fields, the guests had a ready view of the activity passing on Central Avenue a few feet below them. Those with luxury suites may have had access to their own private balcony above the hotel's entrance, seen in the view below. (Photos courtesy of Arkansas History Commission.)

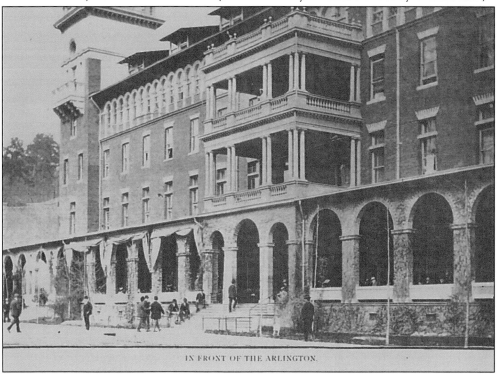

IN FRONT OF THE ARLINGTON.

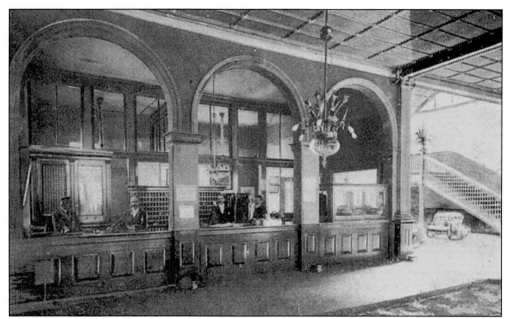

Guests alighting from fine coaches at the front steps of the Arlington would have stepped into a grand lobby and then visited the registration desk, which was modeled after the hotel's exterior arches. After checking in, the guests would have followed the bellman to the right and taken either an elevator or the sweeping staircase to a room on one of the hotel's five floors. The hotel's 1893 opening was described as follows: "Nothing that contributes to convenience and comfort has been omitted. Quick elevators communicate between floors. There is a barber shop, Western Union telegraph office and news stand, also billiard room and bowling alleys, which are frequented by both lady and gentlemen guests." A 1914 booklet added, "Concerts three times daily are given by the Arlington Orchestra," during a period that found the Arlington still commanding a lead in the luxury hotel competition of the city. (Photos courtesy of Arkansas History Commission.)

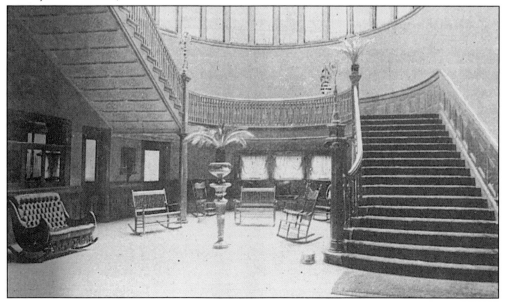

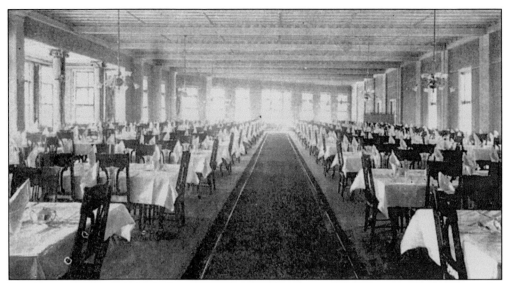

The luxury of the hotel's lobby extended throughout the Arlington and especially to the fine dining room (above). Literature during the hotel's first year of operation described what awaited hungry guests: "The main dining hall is 120 feet in length and 60 feet in width, with light streaming in from windows on three sides, overlooking the park in front and the mountains on all sides. The chief pride of the management is its cuisine. Modern chefs are in charge of the kitchen—every part of the country and the world is drawn upon to supply its tables. The ceiling is of ornamented paneled steel and the furnishings are in ivory and gold, forming a rich and pleasing effect. There are two ladies' ordinaries (restrooms) in connection, the main dining hall is richly carpeted and sumptuously furnished with a seating capacity of 500 guests." After a fine meal a guest might have retired to the Arlington's Sun Parlor (below), which claimed that "no sweeter or more restful room can be found anywhere." The 1913 message on this postcard mailed to Cleveland, OH, read, "Went to the alligator and ostrich farms, a long walk but we enjoyed it."

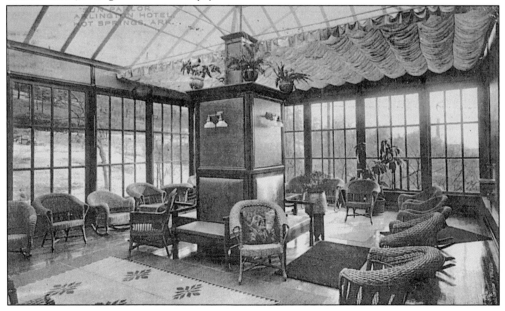

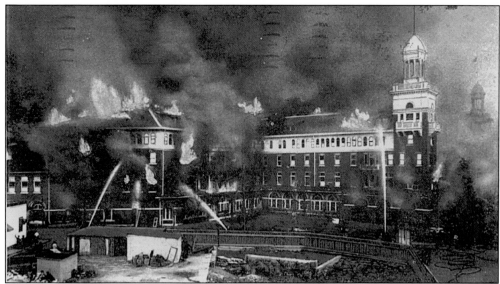

The grand Arlington Hotel had barely reached its 30th birthday, in April of 1923, when tragedy struck. Smoke was detected at around 3:00 in the afternoon, arising from a wiring problem in the basement; it seemed a minor, containable problem at first. So confident were guests of the hotel, among them famed detective William Pinkerton, that they sat on the veranda smoking cigars; when the extent of the fire became known, it was too late to even retrieve their belongings from their rooms. Thousands gathered on the surrounding streets and mountain paths to watch the flames filling the sky, as fire and police forces attempted to rescue guests, many by ladder from the upper windows. Col. John Fordyce came on the scene with a special gas mask from his home and assisted in one final sweep of the smoke-choked hallways, assuring that all guests were out. It was too late then to save the building, for the Arlington was doomed. The one casualty was fireman George Ford, father of seven, who died under a collapsing wall. The view the following morning, April 6, found only a few ghostly arches standing, where the day before guests had sat on the veranda and watched busy Central Avenue.

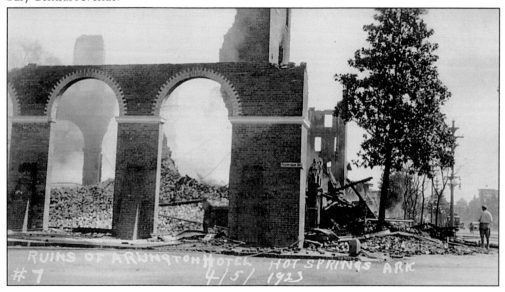

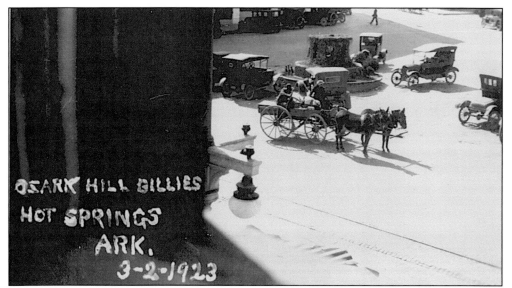

Guests of the Arlington over some three decades had watched from its porch the evolution of transportation, with the transition from horse-drawn buggies to automobiles. This view looked up Central Avenue toward its intersection with Park, where the "Ozark hillbillies" had likely just passed in front of the Arlington, their wagon surrounded by Model T Fords going in all directions. Such imagery gave rise to Arkansas hillbilly characters such as Lum and Abner, Ma and Pa Kettle, and the creations of comedian Bob Burns. Little more than a month after this March 2, 1923 photo, the hotel burned in the fire seen on the previous page.

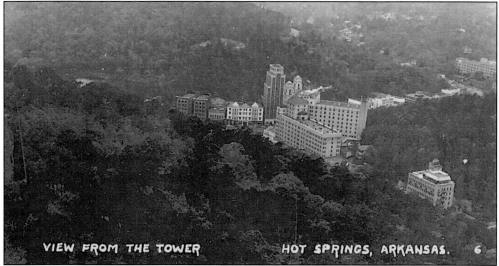

As they surveyed the smoking ruins of the Arlington, the hotel's owners vowed to rebuild, and they were as good as their word. Moving across Fountain Street, where an addition to the Arlington had already been planned, the third Arlington Hotel was built and opened on January 1, 1925. The price tag for the 500-room, twin-towered hotel was said to have been $3 million. The Arlington's twin wings are prominent in this view taken from the observation tower on Hot Springs Mountain. Noticeable also in this view are the Waukesha Hotel and the Medical Arts building, both located across Central Avenue. To the right is the New Park Hotel on Fountain Street, behind the Arlington.

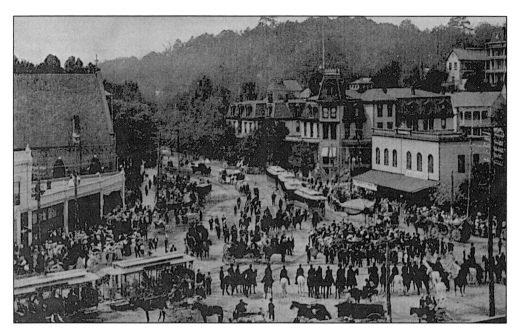

Within sight of the large luxury hotels like the Arlington were often smaller, elegant wooden Victorian-era hotels that had a charm of their own and prices more suited to modest budgets. Such was the case with the Josephine Hotel, seen at the center of the c. 1900 card above. The hotel was located prominently near the junction of Whittington, Park, and Central Avenues, across the street from St. Mary's Catholic Church, on the left. The purpose of the "Gala Day" is not noted, but it brought out a parade of horsemen and streetcars. Seen below is the Josephine c. 1910, after a remodeling that removed a part of the roof; shortly thereafter the building was renamed the Southern Hotel. The Josephine had an advertised capacity of 100 guests for its 50-odd rooms, with rates of $7 to $12 a week in 1909. It was razed many years ago.

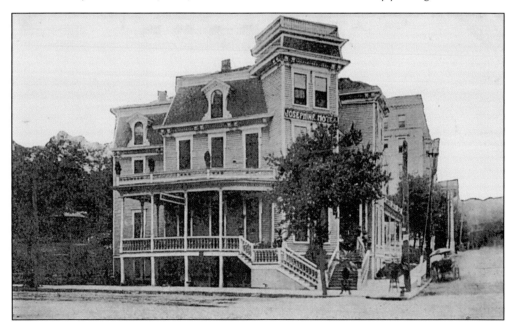

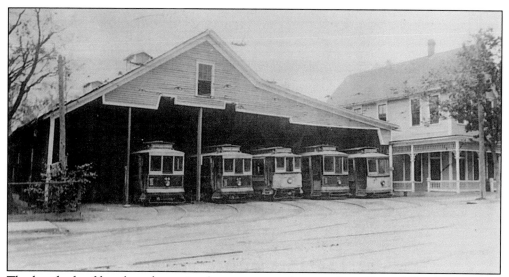

The hundreds of hotels and rooming houses scattered across the valleys of Hot Springs were able to cater to guests of all economic levels, in part because of the city's street car system. First put into operation with horse-drawn cars, the system introduced electric cars in 1893, and soon covered the major arteries of the city. The cars were housed in this "car barn" at 737 Park Avenue, the approximate location of the Park Place Baptist Church today.

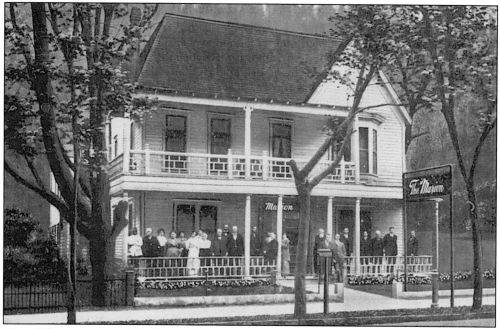

One of the most home-like lodging options in Hot Springs was the Marion Hotel, located at 233 Whittington Avenue and operated by "Doosie" Asbury and Mamie Wallace. In 1909, the advertised capacity was 35 guests, at weekly rates of $8.50 and "upwards." The hotel's quiet location on Whittington Avenue, near the Alligator and Ostrich Farms, made it popular with families on a budget. Operated by a succession of owners over the years, the hotel was torn down by the 1960s. The site is today comprised of parking lots.

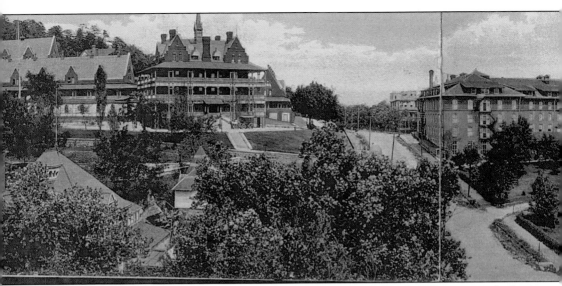

"Many people of wealth are here from Chicago and New York. Uncle Billy went to the horse show ball at the Eastman Hotel with an ex-wife of a millionaire. Andrew Carnegie and young Jay Gould were at the ball," reads a 1910 message from a guest at the Eastman Hotel, the closest rival to the Arlington Hotel for the attention of well-heeled Hot Springs visitors. The message speaks across nine decades to testify to the glory of the sprawling Eastman Hotel. Indeed, one

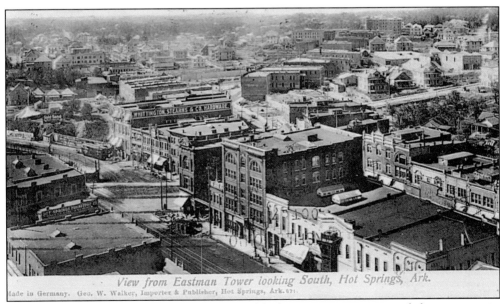

View from Eastman Tower looking South, Hot Springs, Ark.
Made in Germany. Geo. W. Walker, Importer & Publisher, Hot Springs, Ark. 671.

One of the Eastman's most noted features, visible from many points around the city, was its observation tower. It is referred to in an 1894 tourist guide as, "rising to an elevation of nearly two hundred feet (above the ground level) and revealing to the guest who scales its dizzy heights a magnificent cyclorama of mountain and vale and forest stream, which well repays the exertion of the ascent." "Guess I told you about this tower from which one can see the city, it is too high to climb so they now have an elevator," read the card's message in 1909.

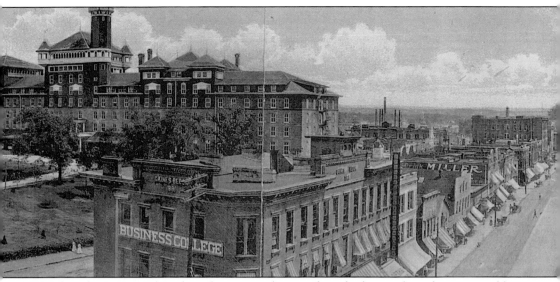

guidebook said in 1914, "There have been several years when the better class of visitors could not have been accommodated but for the commodious Eastman." An 1894 guidebook said, "The hotel sprang up like another Aladdin's palace, but eight months elapsing from the beginning until ready for occupancy in May, 1889." With 520 guest rooms, there would never be a larger hotel in Hot Springs.

Hikers and horseback riders visiting the summit of Hot Springs Mountain were treated to a scene more out of the Bavarian Alps than the American South. Peeking through the trees, the soaring observation tower of the Eastman gave an impression of storybook castles in distant lands. "I think this is pretty, don't you?" penned Elbert T. Beldin on the back of the card in 1911.

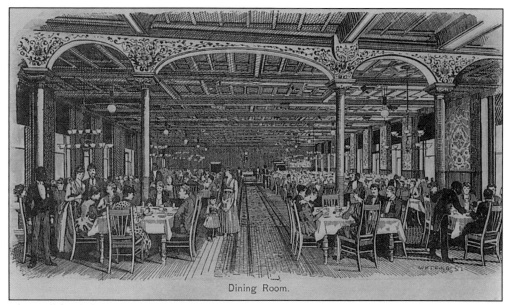

Dining Room.

The well-heeled guests of the Eastman came expecting to dine in a manner to which they were accustomed, and they were not disappointed. Said an 1894 guidebook, "the cuisine of the Eastman is of such high character, and the appliances in the kitchen are so perfect, that nothing further is to be desired. Any description of the Eastman omitting reference to the grand dining room would be playing Hamlet with Hamlet left out . . . Thanks to the perfection of the refrigerator car system, the choicest meats, game and delicacies from all parts of the world can be served to guests here." The card below bears a 1910 message written in Polish, mailed to Chicago, with a photo of one of the fine coaches used by the Eastman to take guests around Hot Springs. Available to the guests, according the guidebook, were "card parties, theater parties, exploring trips among the mountains, square and round dances, and concerts by the hotel's orchestra."

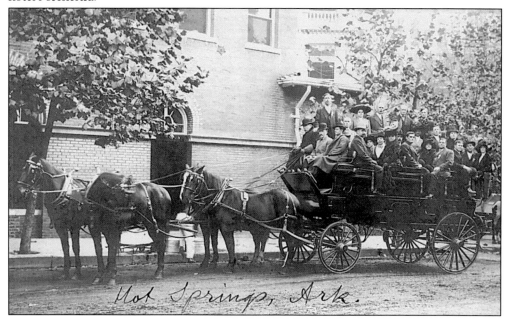

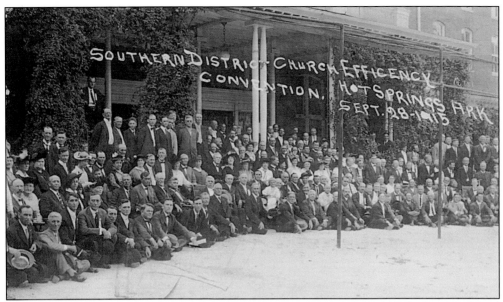

Hot Springs has long been a favorite Arkansas convention city, and in 1915 the Eastman Hotel hosted the Southern District Church Efficiency Convention. Exactly what that was has been lost in the years that have passed since this well-dressed crowd posed in front of the hotel. The card below offered a look at the end of the hotel opening onto Valley Street, an easy spot to hop on a street car for a trip up to Bath House Row a few blocks north. "I feel I have benefitted some from the baths here," penned the visitor writing home to Pennsylvania in 1927. The hotel was operated for a time under the name Kingsway (for owner George King), but reclaimed its famous name in 1937 under new ownership by the Southwest Hotel Company. The Eastman was taken over by the U.S. Army in World War II as an annex for the Army & Navy Hospital; it was sold as surplus after the war and then demolished in the 1950s. The site is partially occupied today by the Federal Building and U.S. Court House.

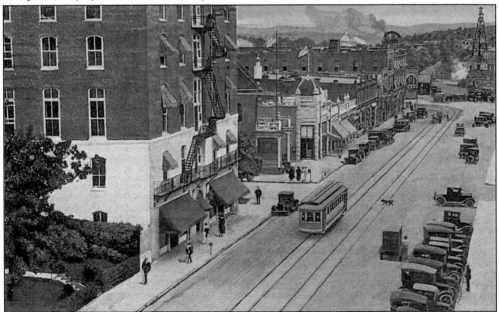

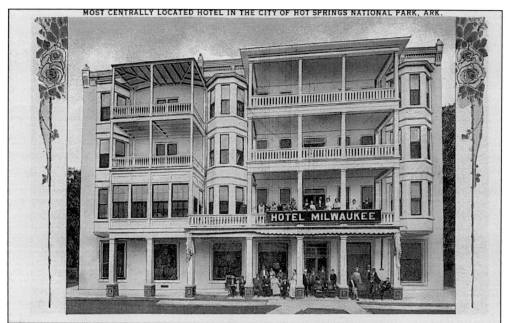

The Hotel Milwaukee was located on Exchange Street and a block off of Central Avenue, a site that led the management to promote it as "the most centrally located hotel in the city." At the time of the *c.* 1915 card above, a new top floor had recently been added to the Milwaukee because of the hotel's popularity. Advertising for the hotel at the time read, "Every room has an outside exposure, window and view." Rates were quoted at $15 to $21 per week in the prime winter season, and lower in the warmer months. In the *c.* 1935 card below is the lobby of the Milwaukee, which was mentioned as follows in an ad in the weekly *Visitors Bulletin*: "enjoy our cool and comfortable lobby—Home-like and restful atmosphere, Dr. H. D. Ferguson, Prop." Dr. Ferguson was a chiropractor; his establishment quoted daily room rates in 1935 of "$1 and up." The Milwaukee has been gone for some 20 years; today, this site is a parking deck.

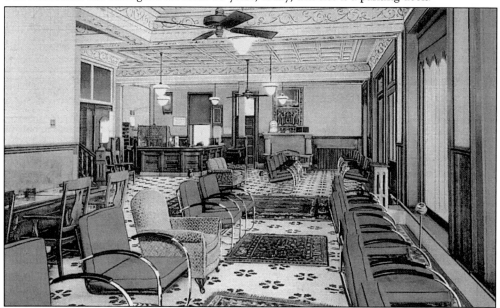

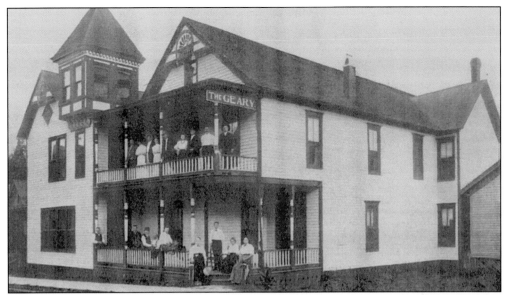

Only a half-block from the sprawling 500-room Eastman Hotel was the compact Geary Hotel, located on Spring Street. Opened by Irish Immigrant John Geary at the turn of the 20th century, it operated from 1907 until 1967. With a location just two blocks from the train station and bath houses, the Geary was popular with tourists of modest means. Operated by Nee L. Geary, the quoted room rate in a 1915 guidebook was 75¢ per day. Today the site is a vacant, grassy lot.

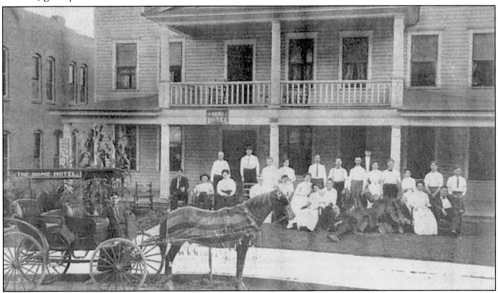

As if to lay the greatest claim on "home style" accommodations, Mrs. A.A. McCullough operated for years the Home Hotel at 133 Chapel Street, a block off of Central. A 1914 guidebook advised of Mrs. McCullough that "her guests can vouch for the success she has attained, and go home with only words of praise for her untiring efforts to make all feel at home." In this view the hotel's "shuttle" service is parked at the curb, a buggy with the Home Hotel name on the side. The frame building survives today, and is now operated as the Key West apartments.

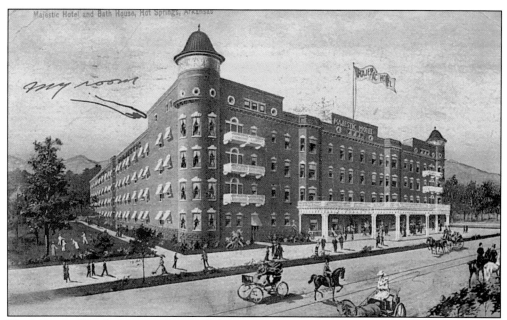

The Majestic Hotel was erected on Park Avenue in 1902, just down from the triple intersection of Park with Central and Whittington Avenues. A 1909 guidebook described the Majestic as "the newest of the large hotels" in Hot Springs, denoting its competing role with the larger but older Park and Arlington Hotels. All four floors were considered "ground floors," as each opened onto the mountainside behind the hotel. "I find Hot Springs a nice place but society bad—all Democrats," was the message penned to Indiana in 1910; denoted on the front of the postcard is the guest's room location. In the c. 1960 card below, the years had brought major changes—the cone tops were gone from the towers of the old section (to the right), and a 1926 apartment addition had been added to the center. In the 1950s the Lanai Tower was added to the left, wrapping around the back of the complex to surround a large pool area.

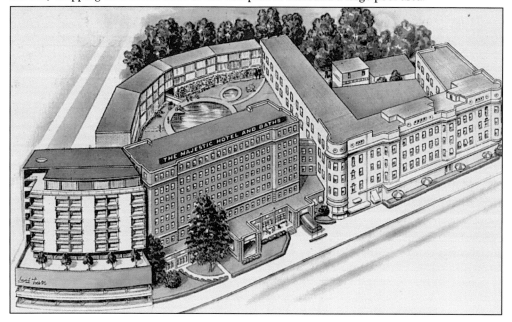

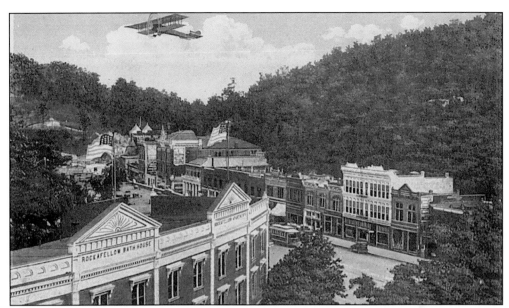

Hot Springs hotels were fixated on towers at the turn of the 20th century, and postcard views taken from those lofty perches were popular. In this *c.* 1920 view, the camera looked from atop the Majestic across the top of the Rockafellow Hotel and Bath House (lower left) toward Central Avenue. The bi-plane flying overhead came from the imagination of the postcard printer, and was intended to catch the eye of the browsing tourist. The Rockafellow was the work of Charles N. Rockafellow, a pharmacist who came to Hot Springs in 1866 and erected the striking building in 1900, shortly before his death. The building curved around the end of Park Avenue, bending toward the intersection with Central just to the right. Room rates ranged from $5 to $17 a week in 1909 guidebooks; a single bath in that era of the enterprise went for 35¢, and a course of 21 baths cost $6. The photo below was taken around 1957, just a few years before the landmark structure was razed in 1963; today the site remains a vacant lot.

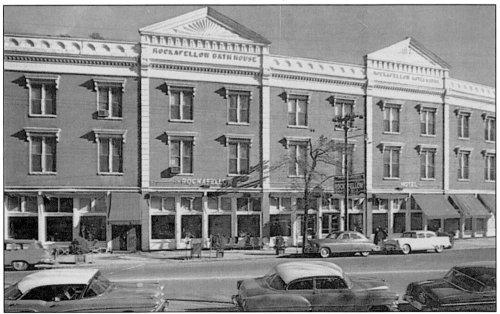

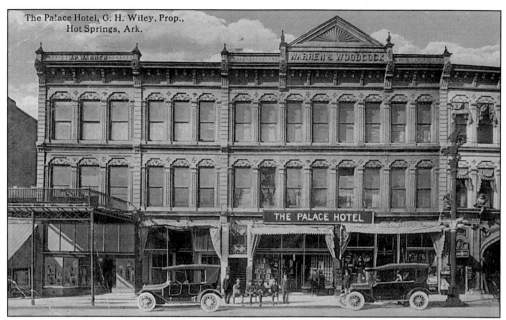

The Palace Hotel, G. H. Wiley, Prop.,
Hot Springs, Ark.

Above: The Palace Hotel, housed in the Warren & Woodcock building, was located at 414 Central Avenue. Built around 1890, the structure first housed the U.S. Hotel; the name had changed to the Palace by around 1910. A 1910 tour guide quoted room rates as "$1 a day, $5 per week and up." The building burned in 1928, along with much of the block.

Below: Among the several small hotels on Exchange Street, which runs a block west and parallel to Central, was the New Richmond Hotel, built in 1888 as the Irma. Given the "new" label after a remodeling, the hotel sat next to the Milwaukee Hotel (p. 74). The New Richmond catered to budget-minded visitors, with rates under $10 a week early in the 20th century. A 1914 guidebook advised that Mrs. F.B. Elliston was the proprietress, and she boasted that her hotel had 50 outside rooms, electric lights, and call bells. She promised that "Visitors desiring pleasant surroundings and a convenient location will be pleased with the New Richmond." The building was razed years ago, and the site is now a parking lot.

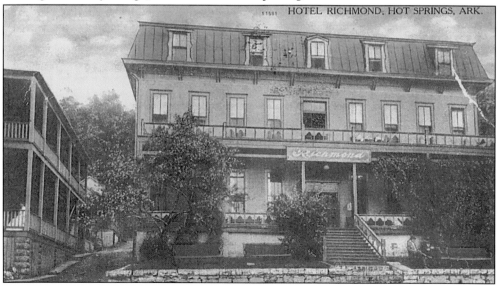

11581 HOTEL RICHMOND, HOT SPRINGS, ARK.

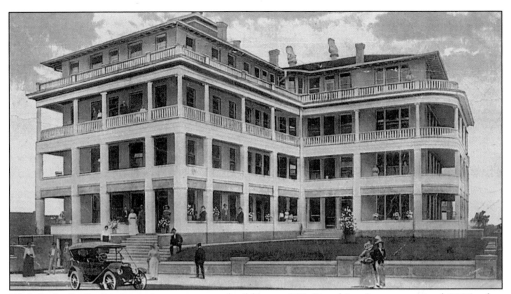

F.M. Sigler built this imposing apartment building at 333 Ouachita Avenue around 1906, after losing his Orange Street boardinghouse in the fire of 1905. The Sigler was operated as more of a higher-class boardinghouse than a hotel. The above c. 1915 card offers a good look at the multi-decked sweeping porches that allowed residents a place to sit and rock while watching streetcars pass. Room rates were quoted at $20 a month at the time. The c. 1930 card below was found in each of the Sigler's rooms; it was intended to encourage the guest to order Hot Spring's famed Mountain Valley Water, delivered to the room and charged to the guest's hotel bill. A guest could have a half-gallon of the water delivered for only 35¢, or as much as 12.5 gallons delivered at once for $3.25. "Indicated as aid in treatment of faulty elimination," the water appealed to the ill and infirm who were at the Sigler for lengthy stays. In a 1935 weekly *Visitors Bulletin*, an ad for the business stated it had been "For 39 years under the personal supervision of Mr. and Mrs. F.M. Sigler." The Siglers must have seen considerable changes from the vantage of their building's sprawling porches, witnessing the horse-and-buggy era, a great World War, and the Great Depression, along with thousands of guests over the years. After failed efforts at restoration, the Sigler building was torn down in the mid-1990s; today a branch of Summit Bank occupies the site.

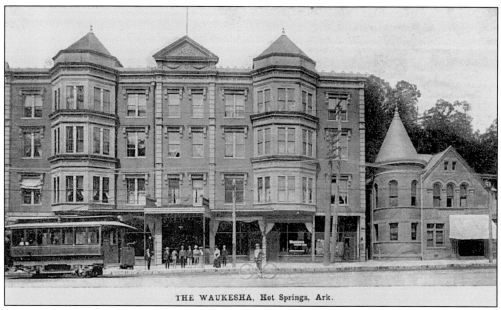

THE WAUKESHA, Hot Springs, Ark.

The Waukesha Hotel at 240 Central was built around 1900 and witnessed six decades of history on Central Avenue. The hotel is seen above c. 1900; a passing streetcar is heading south on Central. Remodeled in 1915, guide books promoted its steam-heated hallway that connected the hotel to the Rector Bath House, seen to the right. By the time of the c. 1955 card below, the end was nearing for the Waukesha, which joined the decline of a number of Hot Springs' hotels. The Rector Bath House had closed in 1925 and was razed to allow construction in the 1930s of the Medical Arts building, the corner of which is visible to the right. The Waukesha was demolished in 1960; the Aristocrat Motor Inn (today apartments) was erected on the site.

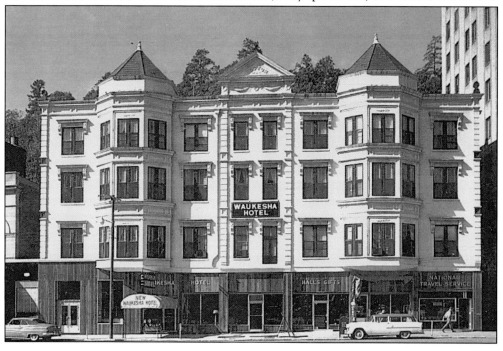

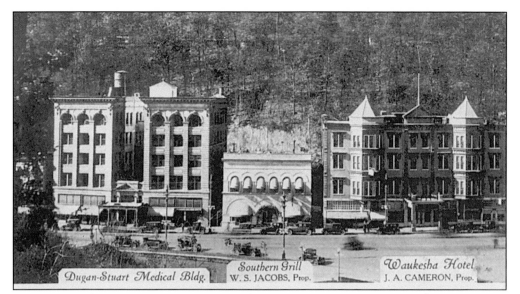

Dugan-Stuart Medical Bldg. Southern Grill
 W. S. JACOBS, Prop. Waukesha Hotel
 J. A. CAMERON, Prop.

This c. 1930 photo was taken from the porch of the Arlington Hotel, located across Central Avenue from the Waukesha. Though the Waukesha is gone today, two other historic buildings in the photo survive. At the far left is the Dugan-Stuart Building, erected in 1904 to house medical offices. The distinctive identical splayed wings, capped by large cornices, make the building one of the most architecturally significant structures in the city. In the center of the photo is the Southern Grill, built in 1893 as the Southern Club.

The Southern Club, built in the Romanesque Revival style, opened in 1893 as an upscale gambling house. It was operated by Charles Dugan and Dan Stuart, who also built the office building next door in 1904. Operated for years as the Southern Grill restaurant, as well as a gambling hall, its gambling days ended in 1967 when Arkansas governor Winthrop Rockefeller shut down the town's illegal gaming. Since 1970, the building has housed Josephine Tussaud's Wax Museum, a must-see tourist attraction for all ages visiting the city. (Photo by Ray Hanley, 2000.)

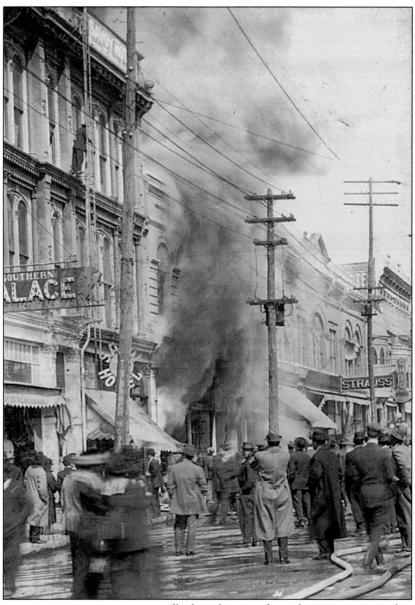

Hotel guests were sometimes unexpectedly forced to cut short their visit, as was the case on March 7, 1913, at the Savoy Hotel, located next door to the Southern Palace clothing store. Two weeks after the fire, one of the Savoy's unfortunate guests wrote to a friend in New York, "How are you all—I got burned out of the hotel. Believe me I come out, too." The inferno began in the Mattar brothers' oriental rug shop, causing severe damage to surrounding buildings, as well as several deaths and injuries. In an adjacent shop the bodies of Charles Carey and E.J. Reynolds were found. Business partners for 28 years, the two were found in a remarkable arrangement: "the head of Reynolds was lying across the shoulder of Carey," reported a newspaper account. "That the charred and mangled bodies were found together was something of a comfort to the distressed widow and orphaned young lady daughter of Mr. Carey." The fire did $200,000 in damages; the Savoy Hotel building was restored and still stands, though no longer as a hotel.

$25 REWARD

For the arrest of one W. R. Gannon, weighs about 150 pounds, height about 5 feet 8½ to 9 inches, slightly stoops in walking, dark hair, bad teeth, eyebrows connect, shoes No. 8, hat 7⅛, incessant cigarette smoker, frequents saloons, low dives and gambling halls, writes a good hand, is a fair painter, had on light suit of clothes with Morris Bros.' tag in coat collar and straw hat when last seen. Wanted for embezzlement. Arrest and notify by wire.

Age 33 to 35

Irish American

A. R. ANDERSON,
SHERIFF HARRIS COUNTY,
HOUSTON, TEXAS

During the early years of the 20th century, Hot Springs' reputation as a wide-open resort sometimes drew "shady" characters, often fleeing the law enforcement of other locales. Thus, in the daily mail of the Hot Springs police chief came postcards like these from 1904, seeking wanted felons who might have taken up residence in any of the hundreds of rooming houses and hotels of the Spa City. In the top card the sheriff from Harris County, TX, gave the wanted man's description, including even his hat and shoe size. Wanted for embezzlement, the felon, W.R. Gannon, was said to be an "incessant cigarette smoker, frequents saloons, low dives and gambling halls." The card below, from Illinois, sought to apprehend a former railroad freight conductor who was wanted for bigamy.

WANTED FOR BIGAMY.

CHARLES EVANS, alias CHARLES HOWARD. Height, 5 feet 6 1-4 inches; weight, 150 pounds; hair, black, thin at crown; blue eyes; sandy moustache; thin face; rather prominent nose and mouth; talks fast; has something of a stoppage; very quick and nervous. Was a freight conductor for the M. & O. Inquiry should be made of trainmasters and yard masters. He is wanted for bigamy. If located arrest and notify

J. M. CONNERY,
Sheriff of White County, Carmi, Ill.

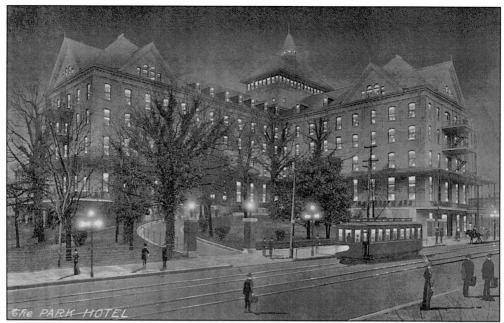

Removed from the hustle and bustle of Central Avenue was the 300-room Park Hotel, located in the middle of several landscaped acres out on Malvern Avenue. Built in 1890, the Park was one of the "big four" hotels, competing with the Arlington, Majestic, and Eastman for upscale clientele. An 1894 tour guide described the hotel's adjoining bath house as having marble walls, and added, "If there is anything in the 'next to godliness' business that is not found in this three story palace of purification, it has yet to become known in civilized communities." Literature for the Park said that to attract "ladies and children unaccompanied by husband or father," the landscaped grounds included playgrounds, lawns for croquet, and tennis courts.

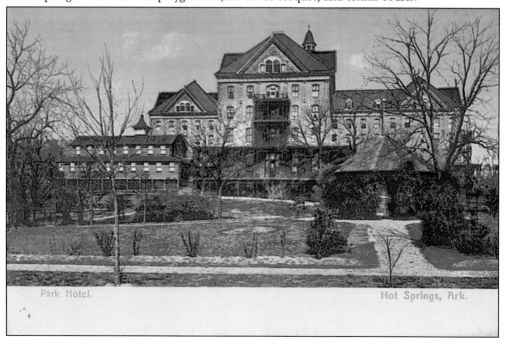

84

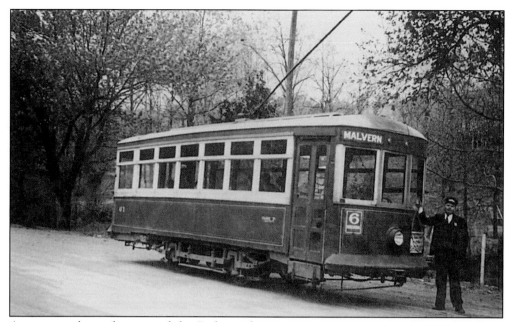

As seen in the night view of the Park on the opposite page, a streetcar line passed down Malvern Avenue, providing easy access between the hotel and the attractions of downtown Hot Springs. The car seen above bears the Malvern Avenue sign; its conductor posed with his stopped car in front of the Park Hotel around 1910. (Courtesy of Arkansas History Commission.)

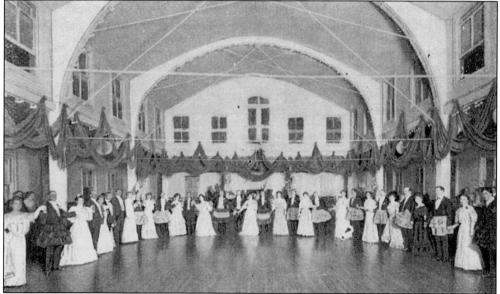

Day and night, there was an endless whirl of activities for the affluent guests of the Park; among the most popular were those found in the hotel's dancing pavilion. Located in an adjoining building, the pavilion was the site of many a festive occasion, as mentioned in an 1894 tour guide: "This handsome structure is devoted exclusively to the votaries of Terpsichore and to other amusements. The Saturday night hop at the Park is a swell event at Hot Springs and the occasion of the gathering of the social clans of all the hotels."

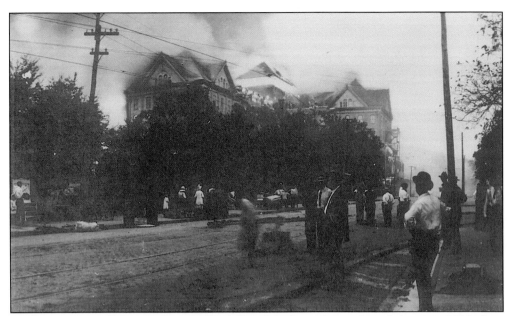

At the young age of 23 years, the grand Park Hotel died on a September afternoon in 1913 when fate put it in the path of the worst fire in the history of Arkansas. A charcoal iron overheated in a cottage near the train station a few blocks away, igniting a fire that ravaged 50 square blocks of Hot Springs before finally being brought under control. Seen here are crowds gathered on Malvern Avenue, watching the advancing flames creep over the Park. (Courtesy of Arkansas History Commission.)

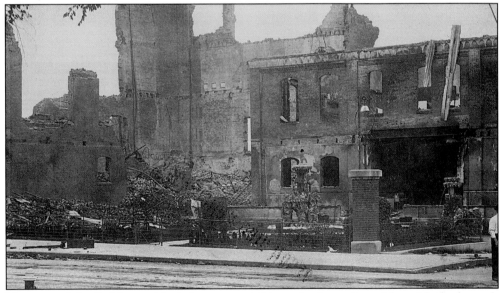

The ruins of the Park's grand bath house are visible to the immediate right, with the burned-out shell of the hotel to the left. The Park was owned at the time by a wealthy Chicago family named Joyce, whose members were in Europe at the time of the great fire. The family, without Hot Springs roots, did not rebuild the hotel. A smaller "New Park" was built in 1930 by other owners on Fountain Street behind the Arlington, where it still operates today. (Courtesy of Arkansas History Commission.)

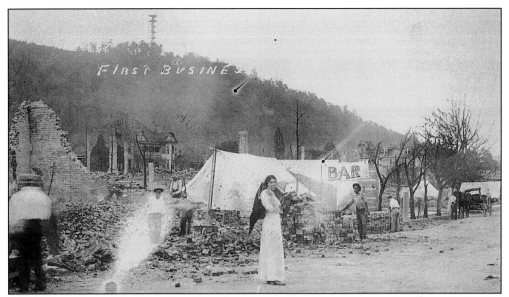

Throughout the burned district, where once stood fine homes, grand hotels, and humble rooming houses, there were erected tents to shelter the thousands of homeless after the 1913 fire. In this view is the tent of the area's "first business" after the fire, operating as a bar. After surveying the 50 square blocks of ashes, it is certain that many must have felt the need for a drink to drown the pain. Atop Hot Springs Mountain in the distance can be seen the city's steel observation tower, from which visitors could have had a panoramic view of the ruined sector.

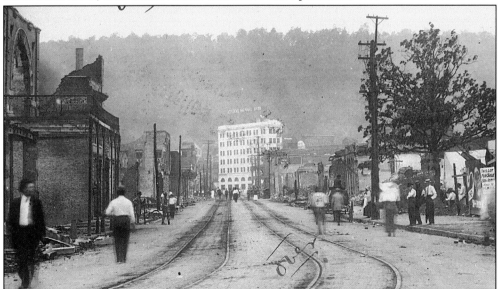

The burned district stretched for blocks, from the destroyed train station and the ruins of the Park Hotel, to the edge of downtown Hot Springs marked by the white towering Citizens Bank in the distant center of this photo. True to human nature in any era, the people of Hot Springs flocked out to view the destruction, as seen here at the southern end of Central Avenue. Photographers were there as well, capturing images that would appear on postcards in a matter of hours, to be sent out to friends and relatives around the nation. (Courtesy of Arkansas History Commission.)

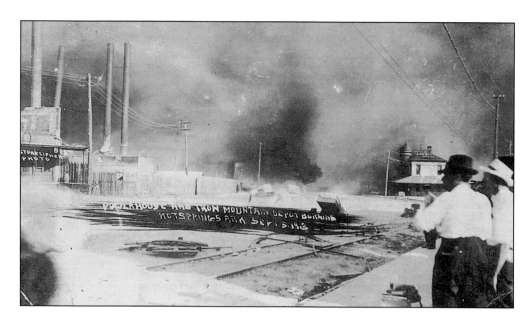

Attempts to fight the great fire of 1913 were hampered, as one of the first buildings to go up in flames was the city's electric plant, seen to the left in the postcard above. The doomed Iron Mountain railroad depot is seen to the right, soon to be engulfed in smoke. With the loss of power to the city, firemen and others were relegated to using horse-drawn equipment for many days. The town's electric streetcars were rendered useless, and mules were deployed to pull trolley cars around town. The fire was finally extinguished with the aid of firefighters brought in by train from Little Rock, but much of what was lost from the Victorian era of Hot Springs would never be rebuilt.

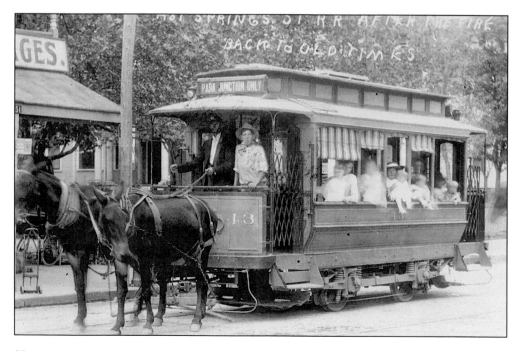

Interspersed among the hotels, rooming houses, and fine homes of the southern part of Hot Springs were churches, ranging from humble wooden structures to grand edifices of cut stone and stained glass. An example of the latter was the Central Methodist Church, where the young women in the c. 1912 card above were members of a Sunday school group. Their handsome church, seen in the card below, was the third on the site, having replaced the red brick spired building in the left inset that had been destroyed by the great fire of 1905. Hotel guests and boarders in the area would have often passed the beautiful sanctuary as they went about the bustling resort city, and perhaps were drawn into its cool recesses for a quiet reflection in the midst of many distractions. Sadly, the fire demon that too often struck Hot Springs returned in 1913, and in doing so wiped out 50 blocks of the city. The Central Methodist Church was again reduced to a smoking shell. Once more it would be rebuilt, and the fourth version still stands today.

First Central M. E. Church South, on Corner of Chapel St. and Central Ave.

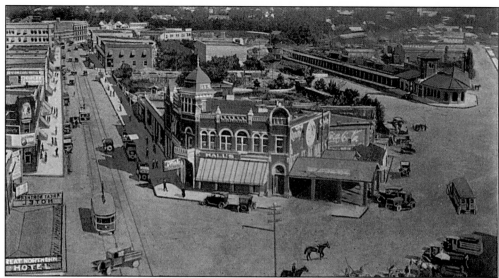

Malvern Avenue would never be the same after the great fire of 1913, but the area revived and has maintained its place in Hot Springs' commercial scene in the years since the disaster. The Great Northern Hotel is visible in the front left corner of this 1930 "bird's eye view;" the hotel was popular with traveling salesmen and those on a budget. It burned in 1947 after a drunken guest fell asleep with a lit cigarette. The photo was taken from atop the Citizens National Bank building; it looks at the Missouri Pacific depot (on the right) that replaced the one lost in the 1913 fire. Also prominent in the center of the photo is the Davis Hotel, which is gone today.

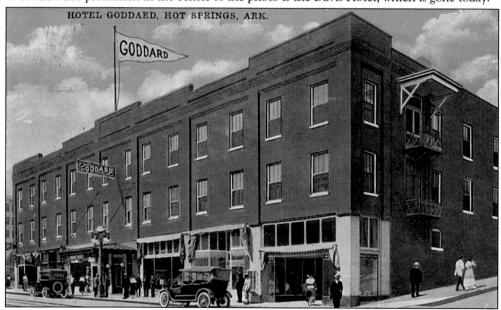

Today Hotel Goddard stands imposing but largely vacant at the intersection of Central and Ouachita Avenues. The hotel was built around 1906, after the great fire of 1905 had devastated the area. A 1914 tour guide had promoted its features of "electric lights, call bells, hot and cold water and stationary wash stands." Advertised rates in 1915 started at $1.50 a day, and $7 per week. The 1921 card above promoted the Goddard as having 150 rooms in a "strictly modern" facility, operating under the management of Mrs. John A. Barton.

90

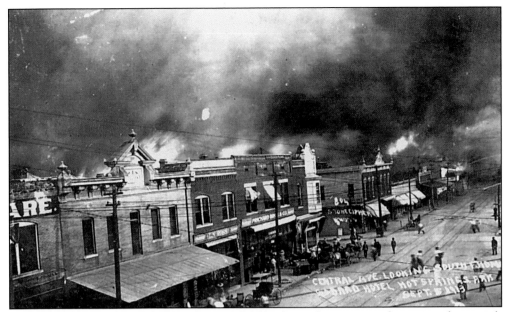

"Central Avenue looking south from the Goddard Hotel" was one of a series of postcards produced of the worst fire in Hot Springs history, occurring on September 5, 1913. Horrified guests, hurriedly being evacuated, would have looked out the windows of the hotel at the smoke and flames filling the sky as 50 square blocks of the city were destroyed. The flames were finally checked, with the aid of fire crews brought in by train from Little Rock, before the inferno reached the Goddard.

The Goddard closed in the 1980s but still stands today, a hulking, silent reminder of a time in Hot Springs history when downtown hotels were numerous and packed with visitors. Efforts have been underway to restore the landmark building for commercial purposes. If successful, the venture would bring back life to the once-thriving commercial intersection of Central, Ouachita, Market and Orange Streets. (Photo by Ray Hanley, 2000.)

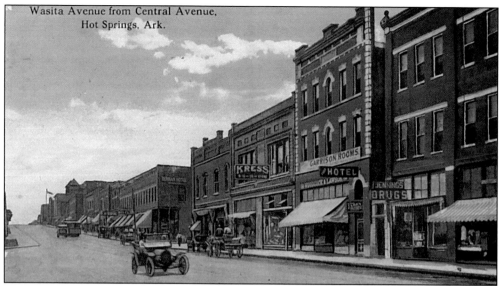

Wasita Avenue from Central Avenue,
Hot Springs, Ark.

Ouachita Avenue was misspelled in the caption for this postcard, published by the S.H. Kress Company for sale in its stores. This view is taken a block up from the Goddard Hotel, and shows such businesses as Jennings Drugs, the Garrison rooming house and hotel, and the Kress Store before it relocated further north on Central. "Hello Cousin Pearl—I'm planning on a nice time at the state fair," was the card's 1914 message, at a time when the fair was held annually in Hot Springs.

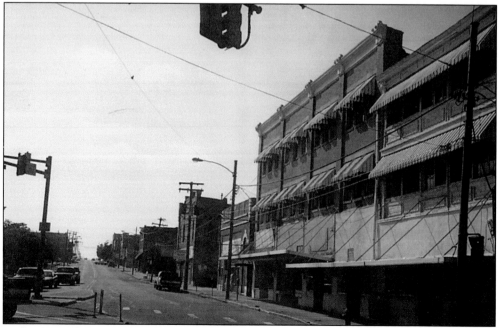

In this 2000 photo of the same view up Ouachita Avenue from Central, much has changed in the 86 years that have passed. The Garrison Hotel in the center of the block has lost its top two floors and is recognizable chiefly by the distinctive arched doorway beneath the overhead hotel sign in the 1914 card above. The building housing the Kress Store is gone, as is the Alhambra Bath House that stood further up the street. (Photo by Ray Hanley.)

Hot Springs' more modest lodgings, such as Ford's Cottages at 616 Park Avenue, were separated from the "Big Four" luxury hotels, not only by many blocks' distance but also by the difference in socioeconomic levels of their guests. Over the decades the Ford buildings fell into disrepair, and all traces of them were gone by the 1980s; the site today is marked only by concrete steps leading up to a weedy, overgrown hillside lot.

Located at 1015 Central Avenue was the Preston Hotel, described on the back of this c. 1915 card as being "the best dollar a day hotel in the city," having "all outside rooms, hot and cold water, modern steam heat, electric lights and bells." The hotel's owner advertised in 1912 that "the hotel's dining room table is supplied from our own poultry and dairy farm." The Preston was either destroyed or severely damaged by the great fire of 1913 and is gone today; the site is now occupied by the Harper Furniture Company.

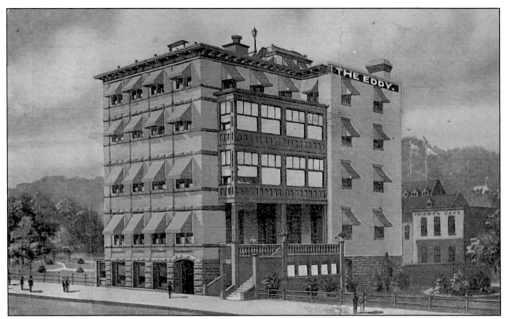

The Eddy Hotel, seen above, was located on Exchange Street. This street, running behind the west side of Central Avenue, was once home to several rooming houses and hotels, including the Milwaukee—all of which are gone today. Erected around 1910, the Eddy was profiled in a 1914 tour guide, as "being furnished with every modern convenience. A number of the rooms are equipped with Cheval mantels and open grate fires. The most up-to-date sanitary plumbing used throughout. One can never get lonesome at the Eddy, as there is always a splendid crowd of intelligent and social people . . . The Eddy caters to the discriminating and fastidious class of tourists and commercial men who appreciate first class service." The c. 1914 photo below shows the Eddy's Ladies Reception Room, where guests mingled and discussed events of the day.

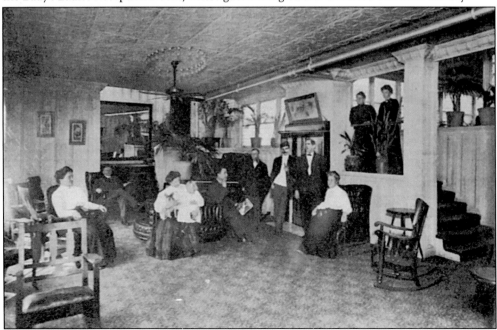

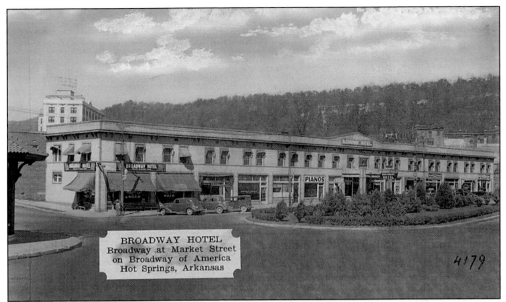

One of the more basic budget hotels was the Broadway Hotel, located at Broadway and Market just across from the Missouri Pacific Depot. The corner of the depot can be seen to the left in the c. 1940 postcard above. The hotel sign on the left end of the building also reads, "toilet in every room," presumably an attractive feature in that day. The hotel building shared space with a piano store, seen at center, as well as a dry cleaners and two cafes. The building visible in the upper left distance is the COMO Hotel, so named for its location at the intersection of Central, Ouachita, Market, and Orange Streets. The c. 1930 card below shows the interior of the Broadway Cafe, along with some of its employees; its location is marked by window awnings in the card above. The cafe promised "family style meals 25¢," a bargain price perhaps made possible by use of the home-canned produce in mason jars, lining the cafe walls. The Broadway was razed years ago to make way for a bank project.

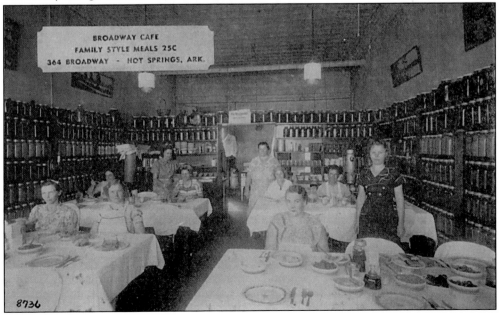

Looking at Things in
Hot Springs, Ark.

Way down in my heart.

In its golden age, Hot Springs was truly a world class playground for a wide variety of people, some rich and healthy, some sick and poor. To accommodate these guests, the city had hotels to fit almost any budget, as has been seen in the preceding pages. Perhaps this comical card, "Looking at things in Hot Springs, Ark—Way down in my heart," was suggested by a couple seen decked out in their finest in the ballroom of the Eastman, the lobby of the Park, or perhaps the grand dining room of the Arlington.

Four

AMUSEMENTS AND RECREATION

In addition to the fine hotels, elegant dining, and numerous shops, visitors also had a wide variety of entertainment options competing for their dollars. Photography studios, bowling, horseback riding, an alligator farm, golf, and tennis—there was an endless variety of activities for guests, and much of it left a postcard record.

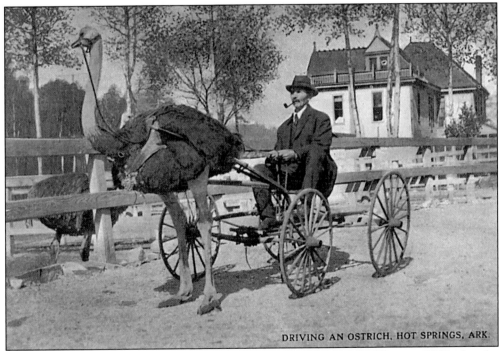

DRIVING AN OSTRICH, HOT SPRINGS, ARK.

One of Hot Springs' biggest tourist draws was created by Thomas Cockburn in 1900 when he opened his Ostrich Farm on 27 acres on Whittington Avenue. Among the 300 giant birds was "Whirlwind," who was pulling this cart in a *c.* 1910 postcard. Mr. Cockburn was sometimes known to drive down Central Avenue pulled by the bird, which stood some 8 feet tall, delighting visitors and residents alike. The farm found a lucrative market for the birds' feathers, then popular for use on ladies' hats. The fad began to wane in the 1920s, however, leading to a decline in the number of birds kept at the farm.

The grounds and activities of the Ostrich Farm provided ample opportunity for postcard photographers. Seen above, a delighted little girl is holding a baby ostrich on a card bearing the message, "Wouldn't you like to be this little girl for a minute?" Note the size of the unhatched eggs on the ground at the child's feet. When full grown the bird in the child's arms could weigh in at 375 pounds. Seen below is a card showing the first sight presented to visitors entering the front gate of the farm—an artful fountain that in this photograph was tempting a small boy. In its last years of operation the attraction was known as the "Ostrich and Wild Animal Farm." The attraction closed in 1953; the animals and the remaining six ostriches were sold to the municipal zoo in Birmingham, AL.

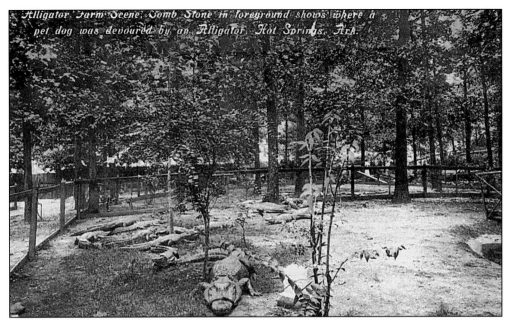

Alligator Farm Scene; Comb Stone in foreground shows where a pet dog was devoured by an Alligator Hot Springs, Ark.

In 1902 H.L. Campbell imported 50 alligators from the Florida Everglades to create "The Gator Farm and Marine Museum" on Whittington Avenue. The notation on this 1912 card boasts that the tourist attraction is "home to 1500 alligators of all sizes, from babies, hardly the size of lizards, to the monster 'Big Doc,' estimated to be 300 years old." The caption across the top of the card denotes the tombstone in the foreground as marking the spot where an unfortunate pet dog was devoured by a resident alligator.

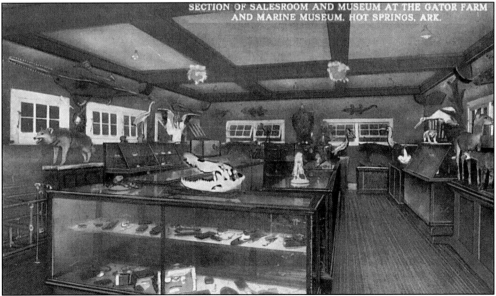

SECTION OF SALESROOM AND MUSEUM AT THE GATOR FARM AND MARINE MUSEUM. HOT SPRINGS, ARK.

The gift shop at the "Gator Farm and Marine Museum" offered a wide assortment of alligator suitcases, purses, billfolds, boots, skulls, and teeth. During the early years, tourists could reportedly purchase a live baby alligator gator for $1. The caption on the back of this c. 1912 card states that the farm's nests and incubators hatched as many as 3,000 of the reptiles each year. The colorful attraction still operates today as the "Arkansas Alligator Farm and Petting Zoo."

In this c. 1912 card a well-dressed couple perch upon a stuffed alligator at the "Gator Farm." Notable are the man's polished walking stick and watch chain, and the ostrich plume atop the woman's hat. Such photos of the era were often printed on postcard stock, which allowed the images to be mailed to friends and family. As large as this stuffed gator was, it was small in comparison to the tourist attraction's largest reptile, which was named "Pine Bluff." Captured near the southeast Arkansas city of that name, the gator weighed over 900 pounds and was 12 feet long.

This "horned rooster" competed for the attention of tourists at the Alligator Farm. According to the caption on the back of the card, the bird's horns were "hard solid bone and over three inches in length." Mailed to Illinois in 1931, the card's message reads, "We saw this freak yesterday at Hot Springs. Also saw the alligators. We are seeing the mountains too. Trying to follow the mountain roads as much as we can."

THE ARKANSAS WONDER

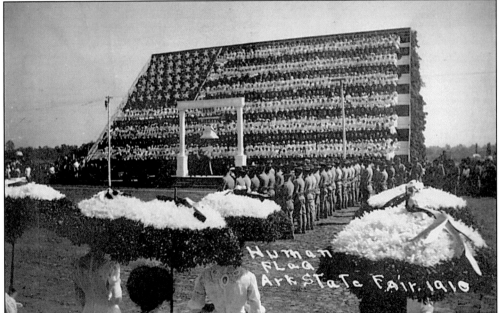

Former President Theodore Roosevelt was the principal speaker at the fifth annual Arkansas State Fair (then held in Hot Springs) in October of 1910. Arriving at Oaklawn Park, he was greeted with elaborate ceremony. Introduced by Arkansas governor George Donaghey, "TR" declared that he was "dee-lighted" with his visit and the entertainment. The human flag behind him was composed of 2,000 schoolchildren dressed in red, white, and blue. While in Hot Springs, Roosevelt met with one of his former "Rough Riders," John Greenway, and took a tour of the city before boarding the train for the return trip to Little Rock.

In the late 1880s a photographer named Norman McLeod opened a studio in a wooded area off Fountain Street, known as Happy Hollow, behind the Arlington Hotel. According to its ads, the popular tourist stop specialized in "Wild West Combination Rustic and Comic Photos." In the *c.* 1905 postcard at the top of this page, the enterprising businessman poses with his trusty camera on a rock overlooking his business. The studio would quickly print images onto postcard stock that could be mailed back home to a customer's family and friends. McLeod sold the business in 1909 to David Anselberg, who operated it until its close in 1948. The verse to the left about the Happy Hollow attraction appeared in a railroad promotional brochure around 1905.

=SAY YOU SAW McLEOD OF HAPPY HOLLOW
(Sung to the tune of "Just Tell Them That You Saw Me")

While walking from my doctor's shop in Hot Springs, Arkansaw,
After bath and treatment for the day,
I met a gent, with troubles bent, who said to me, "O, phsaw!"
Where can I find some pleasure gay?"
I'll tell you, sir," I said to him, "Just listen here; you see?"
Walk up Happy Hollow, sure you can
Pass bath house row and Arlington, and to your right you'll see,
Where you can find McLeod, the happy man."

Just move on 'till you get there, and you will know the rest,
In fact it is the only place to go;
McLeod will make you welcome and treat you to the best,
Of all amusements that he has to show,"

Those donkeys cute, and animals, will thrill you with delight,
The very air will fill your soul with joy:
The music, song and dances, will soon set you all aright.
You'll want to wander back again, I tell you, Mister Man,
For if the biggest crowd of folks you follow,
You'll reach the ground, where joy is found, that will forever stand,
Just say you saw McLeod, of Happy Hollow."

He will show you nature's wonders, and will not charge you a cent,
He will make you feel so funny you will laugh;
You will drop your woes, and strike a pose, just by accident;
And then McLeod will catch your photograph,
You'll feel so proud, and crow so loud, and skip so light and gay,
For it will be as charming as Apollo.
You will have blest that place of rest, and all that you can say,
Is 'Let everybody go to Happy Hollow,"

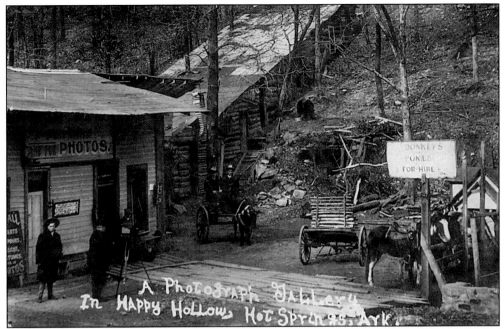

A Photograph Gallery In Happy Hollow, Hot Springs, Ark.

McLeod's Happy Hollow studio was a collection of props ranging from log cabins to wagons and carts, from goats and cattle to tame bears. In this photo the studio building is to the left, with a selection of postcards displayed outside the door. To the right a sign reads "Donkeys and Ponies for Hire;" some of the animals are saddled and ready for an intrepid customer in this *c.* 1908 card.

One of the most popular places to pose was before a log cabin front, dressed in western clothes, surrounded by frontier props. In this *c.* 1910 photo a couple posed in front of the cabin, the woman with a pot of coffee while the man, seated on a barrel, is drinking "liquor." Two prop muzzle-loading rifles lay across a stuffed deer, and animal pelts adorn the windows of the cabin.

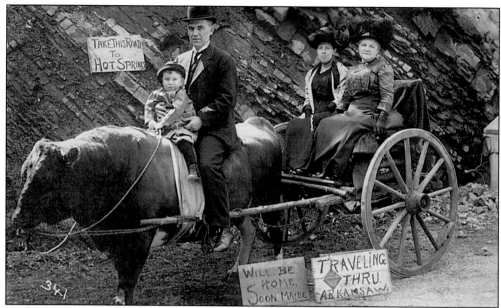

In this *c.* 1910 card, two fashionably attired ladies posed in a cart, while a man and child sat on the very patient, well-trained bull who was one of the "stars" of Happy Hollow with the tourists. The hand-lettered signs, "Traveling Through Arkansas" and "Will Be Home Soon. Maybe.," were trademarks of the studio, appearing on postcards for 40 years, usually with tourists seated in some animal-drawn conveyance.

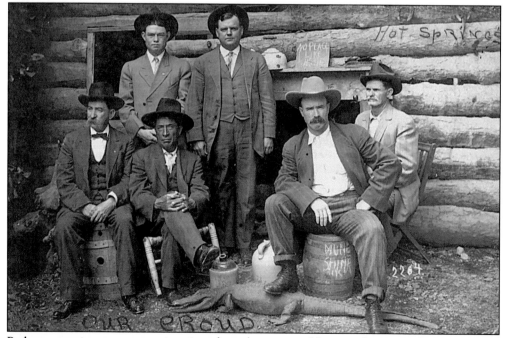

Perhaps assuming stern expressions in order to better resemble an outlaw gang, these men posed in front of a cabin with such props as moonshine jugs and a stuffed alligator. The owner of this postcard wrote on the back to identify the men in the photo, labeled "Our Croud," apparently for inclusion in a souvenir file, for the card was never mailed.

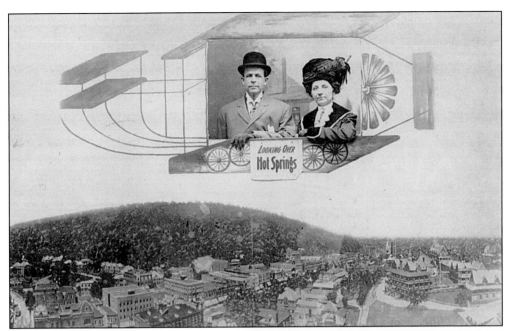

The flight of the Wright Brothers was most likely fresh in the memories of these Hot Springs visitors around 1910, perhaps helping them select the props they wanted for their postcard photo. In the card to the right, a smiling couple was taking a "ride" in a hot air balloon over Hot Springs. In the photo above, a well-dressed couple is seen "flying" over the Spa City. Their photo and airplane prop are superimposed over a photo of the city that was taken from atop the Eastman Hotel observation tower.

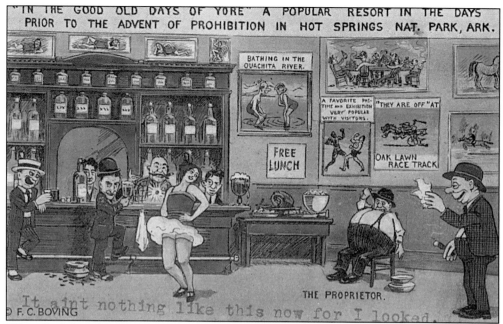

When Prohibition came to Arkansas in 1919, it was perhaps most deeply felt in the famed health resort where liquor had flowed freely. Prohibition generated a great deal of postcard humor, such as this remembrance of "The Good Old Days of Yore." On the wall in this cartoon saloon are posters of the Oaklawn Racetrack and the Ouachita River. The message typed on the card asserts, "It ain't nothing like this now for I looked." Of course, Prohibition or not, Hot Springs boasted its share of "speakeasies" (illegal saloons) where alcohol could be obtained if one knew the password and had the money.

The Happy Hollow Studio was quick to capitalize on the humorous side of Prohibition by creating a prop saloon, complete with whiskey bottles that had originally contained legal liquor. Among the captions on various signs posted are, "If you want to fight go to Mexico or China," and "Shooting craps with your dice not aloud in hear—Ask us for dice." The card's message reads, "Bill, Wife is getting a great deal better. Will be home next week.—Jack"

106

Twins? The Happy Hollow studio actually experimented with its own version of trick photography in this *c.* 1920 card. The same man appears in two photos that are merged into a single image, making it appear as if he is pushing his identical twin in a wheelbarrow. The gentleman in the photo penned, "Your two brothers will be home Thursday if wheel barrow lasts."

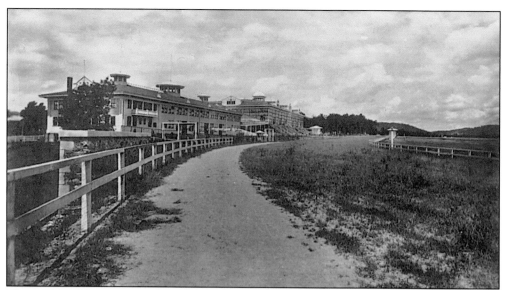

Thoroughbred horse racing began at Essex Park shortly after the turn of the 20th century, and started at Oaklawn Park (above) in 1904. The success of the Oaklawn venture led to the construction of a steam-heated, glass-enclosed grandstand, seen above in 1910. The first season at the track found the parimutuel betting windows not yet finished, so bookies quickly rented tables from which to ply their trade. In one indication of the impact of the sport, as early as 1902 Essex Park owner Simon Cooper opened a "bath house" for horses on Malvern Avenue known as The Horse Pool. He paid the federal government a $30 annual fee per tub to pipe in hot spring water for the horses to soak in. The Horse Pool was destroyed in the great fire of 1913. During Prohibition betting on horses was banned, but the races began again in the early 1930s. Despite disasters like the 1916 tornado, the damage of which is visible below, Oaklawn Park still draws crowds for a 60-day season of horse racing that begins each February.

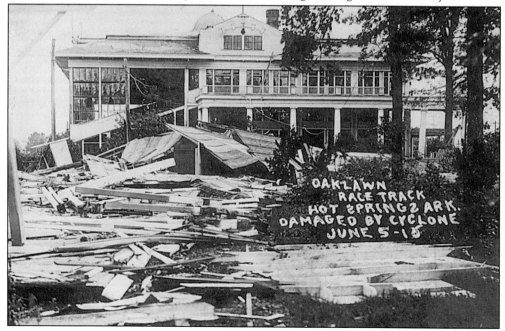

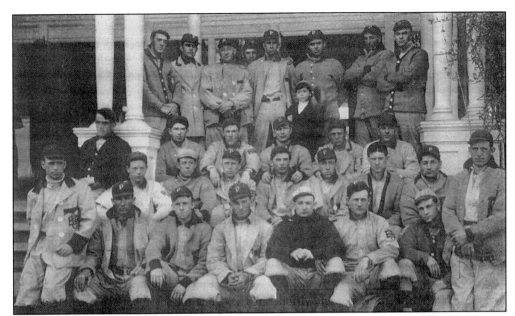

During the first two decades of the century, several major league baseball teams conducted their spring training in Hot Springs; much interest was drawn for exhibitions, when Spa City residents and visitors had a chance to see famous athletes in action. The Brooklyn National team had its own training park on Whittington Avenue; the Boston Red Sox had Majestic Park, on the south side of the city. Seen above around 1910 are the defending world champion Pittsburgh Pirates, who conducted spring training in Hot Springs from 1890 until 1923.

The Gulpha Gorge area, on a creek of the same name, lay at the eastern end of Hot Springs Mountain. It became a popular spot for nature outings by the 1890s. Seen here in 1902, an unidentified family poses in their finest clothes beside the brook, perhaps on a drive after a Sunday church service. The gorge area was purchased by the National Park Service in 1924, and today is home to a popular campground hosting thousands of visitors each year.

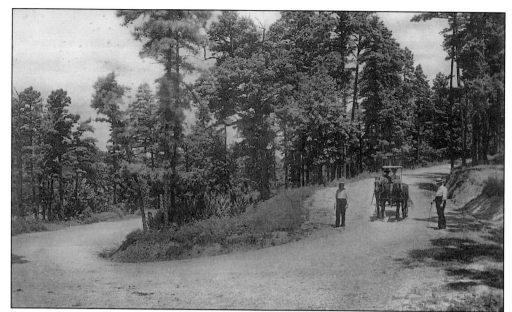

Hot Springs Mountain, rising behind Bath House Row, was a highlight for visitors out for horseback trips, hikes, and buggy rides. A much-photographed spot on the mountain was the horseshoe curve; seen here *c.* 1905, two hikers have paused on it to visit with a couple in a rented buggy. The road led to the 165-foot-tall observation tower atop the mountain.

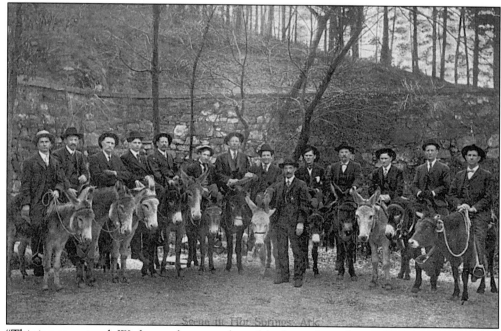

"This is very natural. We have a large number of donkeys where they are rented out to visitors to climb the mountains with. They are very slow," wrote Hot Springs resident Henry Covington to a woman in South Dakota in 1907. The men are all riding small burros, with the amazing exception of the man at the far right, who is actually seated upon a saddled cow. The party posed near the summit of Hot Springs Mountain.

Five

1940 TO 1960:
ERA OF CHANGING TIMES

With the military presence of the massive Army & Navy Hospital, Hot Springs played its role in winning World War II and looked forward to peacetime prosperity. However, the nature of the city was changing as the public's faith in the power of the baths waned. The number of visitors dwindled with the passing away of once loyal guests and increased reliance on rapidly improving medical care. The city was kept vibrant due in part to the presence of very open, but illegal, casino gambling—until this was halted in 1967. Hot Springs watched its famed bath houses close, one by one, and watched its hotels give way to fire, or often to the wrecking ball, in order to make room for more parking lots. Motels and tourist courts had begun their rise in the late 1930s on the outskirts of town, so that the many downtown hotels and rooming houses were no longer needed; one by one, these pieces of architectural history were lost. Still, Hot Springs had much to offer as a vacation destination, and it worked hard to attract new visitors.

By 1949, when this card was mailed, the popularity of the baths was starting to wane. Still, the city and its business community worked hard to attract visitors, using the bathing images as a draw. Ads began to take on a more risque tone that would not have been acceptable earlier in the century.

111

From the 1930s into the 1950s, so-called "sidewalk photographers" were popular along Central Avenue in Hot Springs. Photographers would take pictures of strollers, hoping to sell the images, which were printed on postcard stock and made available to the pedestrian, often within the hour. In this *c.* 1940 photo a couple was photographed, having just passed a cafe and a shop having a sale. Such photos provide a valuable legacy of the fashion of the era.

In this sidewalk photocard an unidentified man strolls along Central Avenue. Over his shoulder can be seen such businesses as Hammon's Oyster House, Emma Merritt's Boarding House, the Swiss Linen Service, and Mae Stover's Massage Parlor. As with the majority of men of the era, the strolling gentleman wore a hat and was smoking a cigarette.

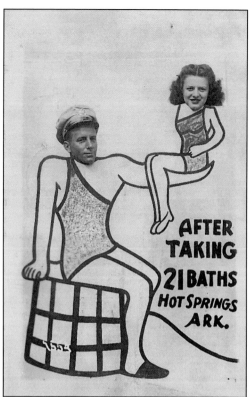

The man on this card was one of many soldiers who visited Hot Springs during World War II, perhaps while enjoying a reunion with his wife. Writing to a contact in Minnesota, the woman wrote, "I'm sending you our pictures so you'll know what we look like when we see you sometime Tuesday. We're stopping by on our way to Fort Louis Washington." The exact location of the photo is not indicated, but very likely it came from one of the Central Avenue studios. Hot Springs served as a military redistribution during the war; several hotels were taken over to serve in this capacity.

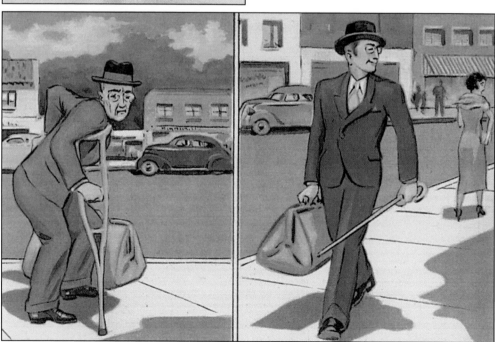

This *c.* 1945 card used the same concept that had been presented in earlier decades—health gains from the Hot Springs baths. While one might arrive stooped in pain, the cartoon asserted, they would go home with a spry step, and in this case a renewed interest in attractive women.

By the 1940s, the rapidly increasing volume of automobile traffic, along with the wartime activity around the Army & Navy Hospital, brought much change to Hot Springs. Trailer City, seen here around 1945, was a business that operated at the corner of Prospect and Exchange Avenues; it offered a place to park that new innovation of the American highway, the travel trailer. Jack Holt's Esso station serviced the vehicles, and his Tasty Grill cafe housed in the end of the building fed the owners of the vehicles.

As visitors began to come more often by automobile than by train, tourist courts began to appear on the outer edges of Hot Springs. One such business was the Coronado Auto Court, seen here around 1940; it was located on Highway 7, south of the Oaklawn racetrack. The notation on the back of the card read, "Rates from $1.50 up, two persons for price of one. Quite, Cozy, Comfy is our motto. All innerspring mattresses and a garage with every apartment. Healthful, mineral drinking water from our own deep spring." The court is gone today; the area now lies in the heart of Hot Springs' commercial shopping district.

Located near the Coronado Auto Court was the Smorgasbord Circle Inn, operated by Sue and Joe Martini. The Martini's advertised their eatery with a very unusual postcard that was die-cut into the folding shape of a chicken. Taped shut and mailed with 3¢ postage, the opened card promoted a hundred-item buffet where a complete "all you can eat" meal could be had for $1.65, including "French Fried Shrimps on Fridays."

The Glendell Court (still standing) was located some 4 miles north of Hot Springs on Route 4 (today Highway 7), on what was then the main highway to Little Rock. The Glendell's location was intended to catch traffic coming from the north on the way into Hot Springs, as it did in the summer of 1952 for a guest who wrote to friends in Kansas: "Staying at this court—have same cabin as Rae had last year. Ride pleasant, cool . . . Drank last of water and ice in Thermos 25 min. before we got to this location. Ice kept perfectly. Drinking the warm mineral water now. Dishes here if we want to cook, refrigerator too, $17 per week for us both. Not bad.—M."

Among the first "tourist courts" in the Hot Springs was the Oaklawn Tourist Court, located on the southern edge of Hot Springs on the "Broadway of America." That designation was given to a coast-to-coast highway completed in 1922 that passed through Little Rock and Hot Springs and on into Texas. The widely promoted road brought many thousands of motorists through Hot Springs, and the Oaklawn Court played host to many of these travelers. The above card was mailed by a minister in 1934, who wrote, "Holding a week's campaign for Pentecost, 600 Sunday night, good spirit. Spoke Sun a.m. at Baptist. Probably hold campaign there when I close Pentecost."

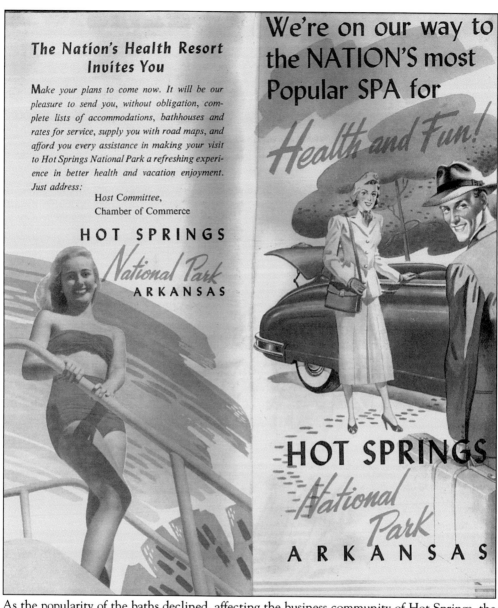

As the popularity of the baths declined, affecting the business community of Hot Springs, the city's chamber of commerce sought to market the area's other recreation and entertainment options. The development of three nearby impoundments on the Ouachita River brought many people, and some still came for the baths. This *c.* 1948 brochure stated that Hot Springs was "unique among the watering places of the world . . . in the number and excellence of its bath establishments, in its medical coterie of distinguished specialists, and in its friendly year round climate and playground attractions . . . you, too, will share the enthusiasm of countless Hot Springs visitors who have said again and again that 'No Other Spa Offers So Much!' "

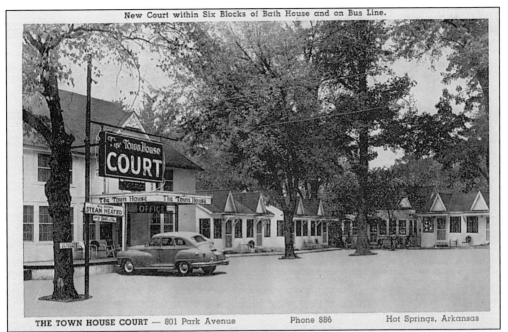

THE TOWN HOUSE COURT — 801 Park Avenue Phone 886 Hot Springs, Arkansas

For the posted price of $2 a day, a 1950 visitor could lodge at the Town House Court at 801 Park Avenue, within walking distance of Central Avenue. "Steam Heat—Air Cooled—Bath in Each Room—Quietest Spot in Hot Springs." A call to phone number 886 could have secured a room at the court, which dated from around 1940 and still stands today.

One of the boldest modern-era hotels was the Aristocrat, erected around 1960 on the site of the Waukesha Hotel, which was razed to make way for the new structure. A look back to the image of the Waukesha on p. 80 will give an idea of the changes in style, lodging, and American life that had occurred over a period of 60 years. Time has marched on for the Aristocrat as well, however; it ceased operations as a hotel and is today run as an apartment house. This guest card from February of 1965 was sent by an Oklahoma schoolgirl, outlining her family's itinerary as they planned to visit Natchez, New Orleans, Florida, Nassau, and San Juan.

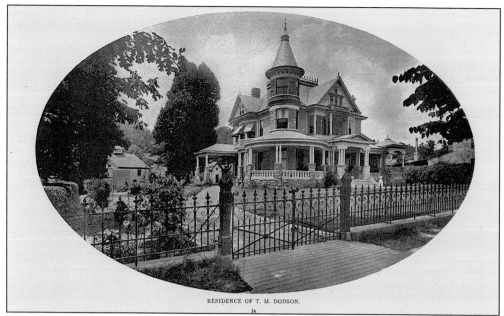

RESIDENCE OF T. M. DODSON.

36

Wealthy businessman Thomas M. Dodson, a railroad contractor, put much of his money into this handsome home at 755 Park Avenue, seen above around 1910. Behind the gate that opened out onto the street of stately homes was not only the house itself, but also various outbuildings and landscaped grounds and gardens, creating one of the true showplaces of Hot Springs society. Mr. Dodson passed on, and while his home survives today, his wonderful garden, gazebos, and most of the wrought iron fence are no more. The bottom postcard from around 1960 was published by the Tower Motel at 755 Park Avenue; most of the motel is out of sight to the left. The name came from Mr. Dodson's home, which stands adjacent to the business. An Indiana visitor on an extended stay wrote on the 1960 card, "Greetings from the Spa, been here two weeks, two more to go. Both taking the baths and treatments."

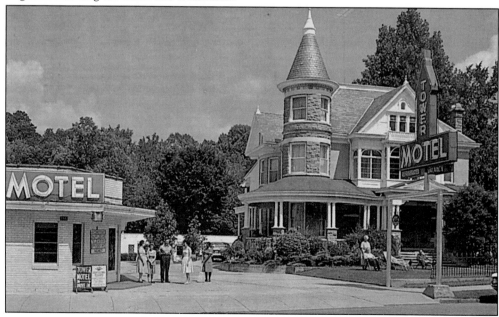

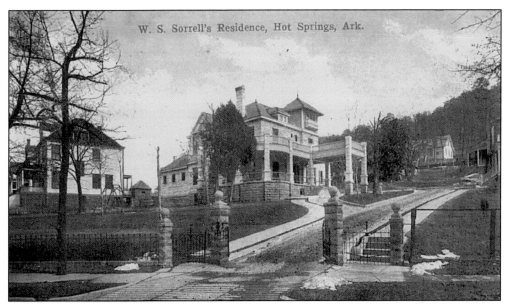

W. S. Sorrell's Residence, Hot Springs, Ark.

Together, these views from c. 1910 (above) and c. 1950 (below) illustrate a remarkable snapshot of what 40 years of change brought to Park Avenue. W.S. Sorrell was the owner of Sorrell's Drug Store on Central Avenue (p. 44), which served the tourists along bath house row not only with medicine, but with a complete line of bath robes and souvenirs. The profits of the store helped Mr. Sorrell build this stately home at 316 Park Avenue, approached by wide driveway and stone pillared gate. Sorrell died in 1927, and his widow died in 1934. By 1950, Mr. Taylor Rosamond had acquired the property and built the Taylor Rosamond Motel (seen below) on what had once been the grassy lawn of Mr. Sorrell's mansion . The motel office is seen near the street, sitting where once was the stone pillared gate. Today the house still stands, as does the motel, which is now called the Villa Motel.

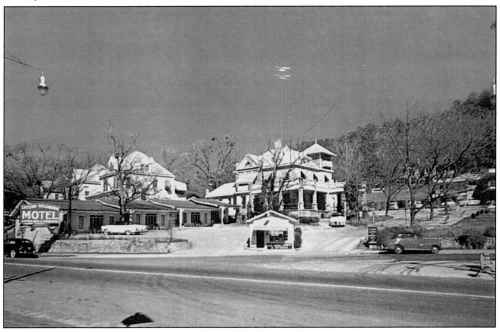

Some of Hot Springs' tourist lodgings tried to bridge the gap between the old-style luxury hotels and the auto-friendly motels of the day. Such was the case with the Velda Rose, "the finest motor hotel in the south," according to the above card. Located at 218 Park Avenue, the motel was only two blocks from the head of Central Avenue. The hotel was named for Velda and Rose Anthony, the daughters of owner Garland Anthony. The 1955 guest card above bore the notation that it was "a place for vacation, a few baths, a check up at Army Navy Hospital." The room displayed here had a television with a large radio perched on top, as well as decorative items on the shelves and coffee table. The c. 1957 card below advises that the motel had 121 rooms "furnished in excellent taste," a swimming pool, barber and beauty shop, and a convention room. At the time of these cards the Velda Rose was owned by Mr. Anthony and managed by Gerald Vanderslice. Today the Velda Rose is gone, but a bit more modern motel operates across the street from the site, under the name Velda Rose Hotel & Spa.

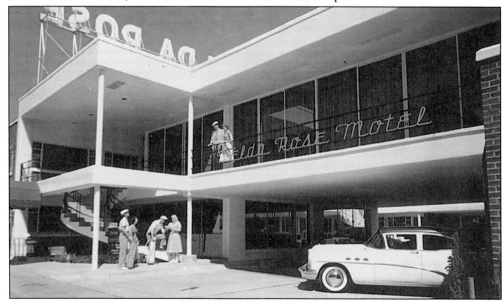

GRACEFUL GERTIE
Tight Rope Artist

THE PIANO PLAYING DUCK

Hot Springs visitors found a popular new attraction in the 1950s with the opening of the I.Q. Zoo (on Whittington Avenue), officially known as "Animal Behavior Enterprises, Inc." Above, "Graceful Gertie," the tight rope walking chicken, was one of the many "educated" animals at the facility. Keller Breland, who referred to himself to himself as an "animal psychologist," opened the unique attraction in 1955, after purportedly having studied with psychology pioneer B.F. Skinner. At the height of its popularity the zoo was featured in *Readers Digest*, *Life*, and *Look* magazines, as well as on numerous television shows. Seen below is an "educated" duck at the I.Q. Zoo, turning on the lamp before demonstrating its musical talent on a toy piano. When the duck finished its routine, it was rewarded with a kernel of corn. "These animals learn by the reward system," asserts the card's caption. "No punishment is used. Once trained they will not forget and will perform automatically for anyone." The attraction relocated and was renamed the Animal Actors Zoo, then Clower's World Famous Zoo, and finally went out of business a few years ago.

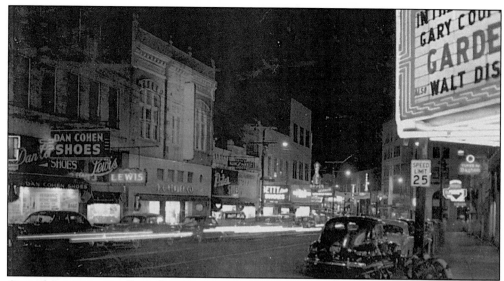

Central Avenue was still a nighttime entertainment mecca in the 1950s, and the Malco Theater was a major draw. The movie playing at the Malco when the photo was taken for this postcard was *Garden of Evil*, a western starring Gary Cooper, Richard Widmark, and Susan Hayward. The card's message read, "Dear Aunt Lucy, We are having a grand time. Are going on a picnic today to celebrate the 4th. Cindy is fine. We had her sheared, she looks like a skinned mouse." Presumably Cindy was the touring family's dog. Today the Malco Theater is home to the Hot Springs Documentary Film Festival, a nationally acclaimed program to preserve and promote the art of great films.

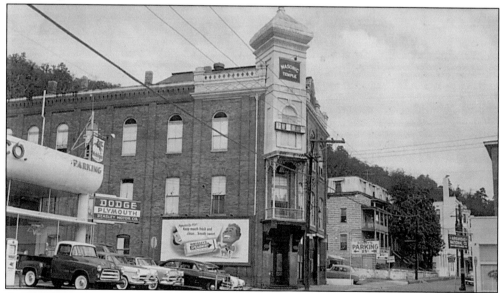

As the 1950s moved toward the 1960s, major changes were in the offing for formerly vibrant blocks of Hot Springs. Exchange Street, running from Ouachita and eventually curving back into Central Avenue, was anchored by the Masonic Temple (seen here), along with the Hotel Richmond (just beyond the temple) and the Hotel Milwaukee (visible in the distance). Today the Dodge dealership is gone, as are all the other buildings in this view; most of present-day Exchange Street is made up of parking lots. (Photo courtesy of Jay Campbell.)

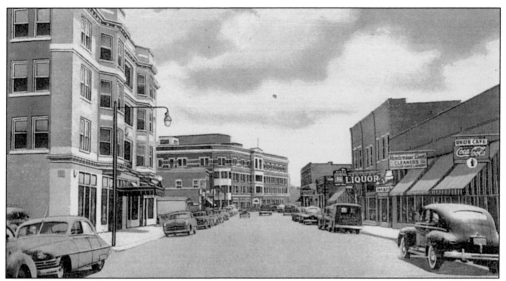

Though the Civil Rights movement was beginning to change the patterns of the economy, this postcard from around 1950 found the largely black business district of Malvern Avenue vibrant and intact. The weekly Hot Springs Visitors Bulletin in 1953 carried a separate "Negro Section" of ads for businesses in this area. A joint ad was sponsored by the National Baptist Sanatarium, seen in the distant center, and the Pythian Hotel, seen to the left in the above card. The ad proclaimed, "We extend an invitation to the Negro population of the United States to come to Hot Springs." Today, with the exception of the boarded-up National Baptist Hotel, virtually all of these buildings are gone.

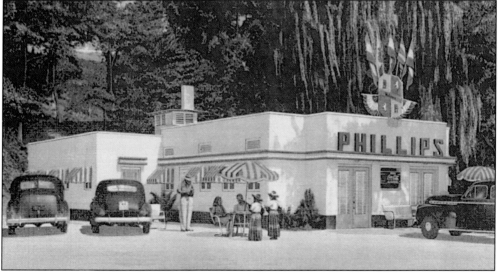

The era of the drive-in diner had arrived by the time this c. 1950 card was made of Phillips Drive-In Coffee Shop at 315 Park Avenue. Diners could eat indoors or outside, with such menu items as Kansas City Steaks and Chops, seafood, and barbecue available. According to the Garland County Historical Society, Phillips was the place to be for high school students on Friday nights after football games. After Phillips was closed, the site was the location of the colorful Vapors Nightclub, the scene of much illegal casino gambling. Today the old Vapors building is home to a religious organization.

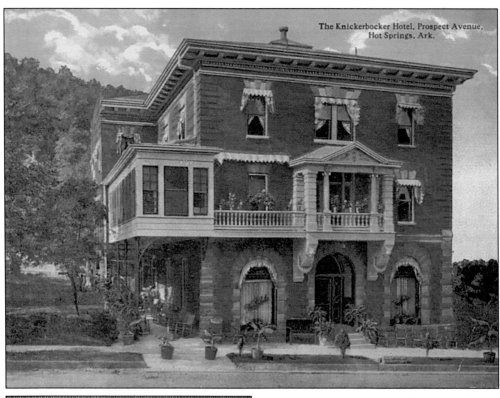

The Knickerbocker Hotel, Prospect Avenue, Hot Springs, Ark.

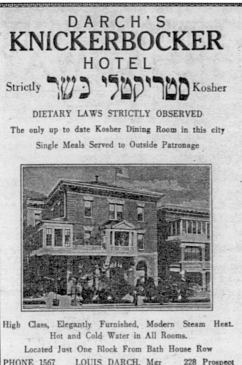

As the 21st century begins, this book takes a look back at the Hot Springs resort that was born in the 19th century. Sadly, much of what has been covered in this little book is long gone—victims of fire, flood, and man's short-sightedness, as he hurries to tear down the distinctive old in order to build the often nondescript new. Happily, government and private interests are working together in many cases to preserve pieces of the city's past. For example, the fate of the Knickerbocker Hotel at 228 Prospect Avenue, just off of Central Avenue, hangs in the balance. Erected at the turn of the 20th century, the hotel billed itself as a "house of welcome, freedom and convenience." At the time of this c. 1910 postcard, the advertised capacity of the hotel was 75, with rates of "$10 a week and up," under the management of proprietor Mrs. E.W. Lauher. The hotel was located near the Levi Hospital, erected in 1914 to serve Jewish visitors and residents. In consideration of its guests, the Knickerbocker advertised in a 1935 guidebook that it was a "strictly Kosher" establishment, with "All dietary laws strictly observed."

In these photographs taken in early 2000 by the author, the Knickerbocker still stands, a hollow shell of the "High Class, Elegantly Furnished, Modern" hotel that it once was. However, an effort is underway to restore the once-proud establishment. Below, the Knickerbocker's logo "K" peeks from beneath multiple coats of paint, on a door through which has passed thousands of visitors over the years, drawn by the promise of better health and good times in the wonderful resort city. It is hoped that the restoration will be a success, lest another of Hot Springs' historic hotels be lost to join those that exist today only on old postcards; hotels like the Eastman, the Park, the first and second Arlingtons, the Milwaukee, the Geary, the Marion, the Josephine, the Imperial, the Rockafellow, the Richmond, the Sigler, the Waukesha, the Eddy, and the Broadway. It is further hoped that this book might inspire those with opportunity and means to join the effort to save a part of the past for the generations to come.

INDEX